MYSTERIES

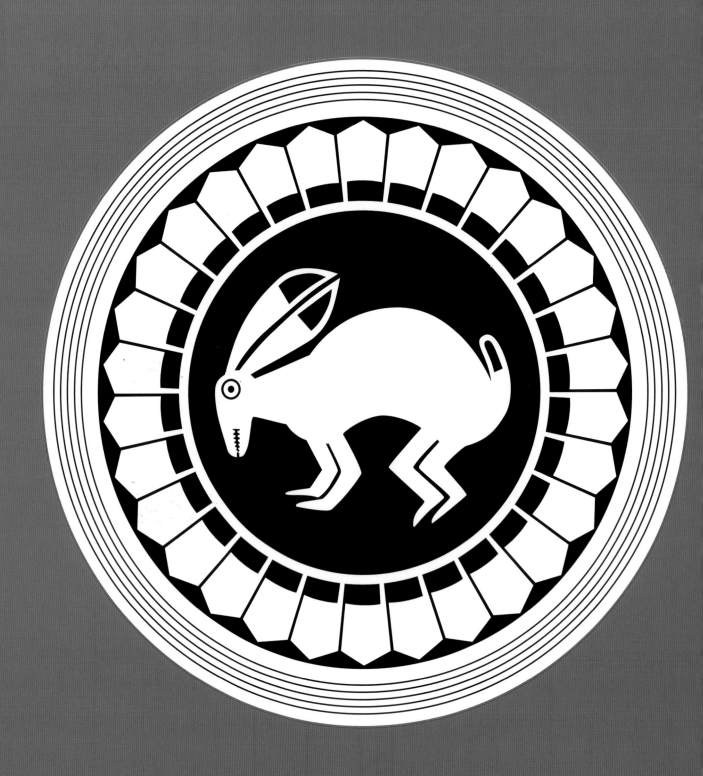

MIMBRES CLASSIC MYSTERIES

RECONSTRUCTING A LOST CULTURE THROUGH ITS POTTERY

Tom Steinbach

BY TOM STEINBACH, SR.
TOM STEINBACH, JR.
AND PETER STEINBACH

Peter Steinbach

MUSEUM
OF
NEW MEXICO
PRESS
SANTA FE

For "Sir Tom"
Tom Steinbach, Jr., son, brother, and co-illustrator of this book,
succumbed to the effects of his rare Wilson's disease
just a few months before completion of our manuscript.
We love you and miss you, "Sir Tom."

Project editor: Mary Wachs
Art direction: David Skolkin
Design: Bruce Taylor Hamilton
Composition: Set in Stone Sans with Lithos Light display
Map: Deborah Reade
Printed in Hong Kong
10 9 8 7 6 5 4 3 2 1

Library of Congress Cataloging-in-Publication Data available.

MUSEUM OF NEW MEXICO PRESS
Post Office Box 2087
Santa Fe, New Mexico 87504

Frontispiece: Revered Rabbit
When people learn to depend upon a particular animal species for continuous satisfaction of their appetites, they learn to venerate that animal. Thus, the rabbit became revered by the Mimbres people as one of their own, a member of their tribe, with an aura of his own feather ring, as seen in this radiant bowl design. In the many bowl paintings by the Mimbreños, the rabbits were drawn with such sensitivity and loving care that they appeared to be revered as blood brothers of the people.

CONTENTS

PREFACE

The author and primary illustrator of this volume, Tom Steinbach, Sr., and the co-illustrators, Tom Steinbach, Jr., and Peter Steinbach, have researched and labored on it over a period of fifteen years assembling, analyzing, designing, and writing a visual history from as many recovered ceramic artworks of this lost, prehistoric people as possible. Because so little direct archaeological information has been unearthed about the Mimbreños themselves, we decided to draw information directly from their pottery designs, which are unique as pictorial representations, or "snapshots," of the Mimbres culture, A.D. 1000–1150.

We set out to create an integrated view of the prehistoric Mimbres people based on pottery paintings that suggest their cultural, religious, biological, and political lifestyles. This has been done piecemeal before but not as a focused effort. Because archaeological digs and anthropological findings have left more unknowns than knowns, our effort required broad research into the possible prehistoric roots of Mimbres pottery designs in Mesoamerica and in the southwestern United States in the post-Mimbres period.

Additionally, we sought to select a sufficient quantity, variety, and quality of Mimbres pottery designs to establish a spectrum of characteristics that would effectively portray the Mimbreños and their unique culture.

The design drawings, which were rendered digitally, are based on ceramics housed in major museums in the U.S., including the Smithsonian Institution, Washington, D.C.; Peabody Museum of Archaeology and Ethnology, Harvard University, Cambridge, MA; and Maxwell Museum of Anthropology, University of New Mexico, Albuquerque, NM.

In the development of Mimbres design drawings, necessary liberties were taken to convert three-dimensional hemispherical bowl designs into two-dimensional flat visual images. The rare original polychrome designs of the Mimbres are presented in approximately the colors of the originals according to the judgments of the author and illustrators. A few designs are reconstructions based on fragments of original bowls. Others are composites in which we used original Mimbres design elements in arrangements of our own creation. Some designs are represented in full color for dramatic visual effect.

The book begins with "Geometric Designs," abstract geometric symbols inside hemispheric ceramic black-on-white glazed bowls. Thereafter, the conceptual layout of this publication places related families of living creatures in groups. The subject groups that follow are "Birds," "Water Life," "Insects, " "Wild Animals," and "The Mimbreños," the people's own active lives. Like so much associated with this ancient culture, the titles we have given pottery designs represent open questions, not definitive answers.

Tom Steinbach, Sr.

INTRODUCTION

In spite of the great mystery that is Mimbres culture, our book draws substantially on the work of our predecessors. We have carefully studied the excavation reports of archaeologists of the twentieth century, the writings of Native American experts from today's pueblos, and the exhibition catalogues of recent years that reflect the current international popularity of Mimbres masterpieces. This introduction gives proper credit to the authors who have influenced our thinking.

The first people to informally explore the small village sites along the Mimbres River were area ranchers such as E. D. Osborn, whose photographs of pottery designs convinced ethnographer Jesse Walter Fewkes of the Smithsonian Institution to visit southern New Mexico and later to collect pottery and publish studies on the subject (1914, 1916, 1923, 1924). Many of the black-on-white and polychrome hemispheric bowls we illustrate were excavated during the 1920s and 1930s at Classic period sites such as Cameron Creek Village (Bradfield 1931), Mattocks Ruin (Nesbitt 1931), and Swarts Ruin (Cosgrove and Cosgrove 1932). Other important Classic period sites are Galaz, Harris, and Old Town. Archaeologists did not work in the Mimbres valley again until the 1970s and later (LeBlanc 1982, 1983, 1986; Anyon and LeBlanc 1984; Shafer 1991) and their work has filled in many gaps in our knowledge. The chronological framework and pottery types we have adapted come from Haury (1936a, b); Anyon, Gilman, and LeBlanc (1981); LeBlanc (1983); and Anyon and LeBlanc (1984). The overview by Stephen H. Lekson was very helpful (1992).

Mimbres people may forever remain a mystery because of the greed of late-twentieth-century looters and collectors. In the 1960s and 1970s, as the painted bowls were widely celebrated for their beauty and charm, their value skyrocketed, leading to the tragic pillaging of sites. Quiet pueblos undisturbed for a thousand years were demolished by pothunters with bulldozers, leaving little for future study. Because of this catastrophe, continuing research on the Mimbres is scarcely possible. Knowledge in many cases can be only speculative. This has led us to depend on subjective analysis of visual and aesthetic evidence rather than on archaeological data in this book.

Our wide-ranging investigations have led us through time and space searching for relationships among the Mimbres, today's Pueblo Indians, and ancient Mesoamerican civilizations. Many anthropologists have asserted that historic and modern Pueblo peoples share artistic iconography and, perhaps, parallel belief systems with the Mimbres (Brody 1977, 1991; Brody, Scott, and LeBlanc 1983; Brody and Swentzell 1996; Carr 1979; Moulard 1984). This is a theory that we enthusiastically share based on our aesthetic analysis.

We particularly gained insights from artist Fred Kabotie's beautiful 1949 study of Mimbres designs from a Hopi perspective. Key concepts that appear throughout our book pertain to Pueblo Indian cultures of today and by analogy, it is suggested, to the ancient Mimbreños. As an example, the "middle place" that Alfonso Ortiz defined as the sacred center of the Tewa village that symbolizes the earth navel or source of all blessings is a concept that we apply to Mimbres pottery design (Ortiz 1969: 21–2). The fact that women now make and paint most Pueblo pottery has convinced many that the same was true for the Mimbres, although this theory is unproven and some potters may have been men (J. J. Brody 1977:115–16). Ethnographic analogy, reinforced by the artistic sensibility of the designs, is powerful evidence to us that Mimbres pots were created by women.

Our search has taken us south to Central Mexico and the Yucatan as well. Scholars have argued that similar motifs, symbols, and perhaps religious beliefs occurred among the Classic Mimbres (A.D.1000–1150), Late Classic Maya (A.D. 600–900), and Early Post-Classic Toltec cultures (A.D.1000–1200). Examples include the horned serpent figure of the Pueblos and the Toltec plumed serpent deity Quetzalcoatl, which share a similar appearance. Twin culture heroes associated with the sun, the moon, and Venus as the morning star also appear among the historic Pueblos and in the famed Quiche Maya epic known as the *Popol Vuh*, supporting a possible interpretation of Mimbres motifs as being regional adaptations of Mesoamerican myths (Brody 1977; Brody 1983; Brody and Swentzell 1996; Thompson 1994). It is not iconography alone that links Mimbres settlements and Mesoamerican cultures but also trade goods such as scarlet macaws, shell ornaments, copper bells, and turquoise. What was the nature of this economic network? Archaeologist Charles Di Peso, based on his excavations at Casas Grandes in the 1960s, argued that an aggressive merchant class he refers to as the *pochteca* brought Mesoamerican-based symbolism and material goods to northern populations. The concept of the pochteca was originally applied to a special class of long-distance traders within post-Classic Aztec society. Recent research seriously disputes Di Peso's theory, but it remains controversial.

Today, if we drive eastward from Silver City into the beautiful Mimbres valley, we can still see sweeping views of arid ranchlands and forested mountains brought together by green cottonwood groves along the Mimbres River. In this place that now seems so remote, it is marvelous to know that once a society of great artists flourished. This book honors their memory and their accomplishments.

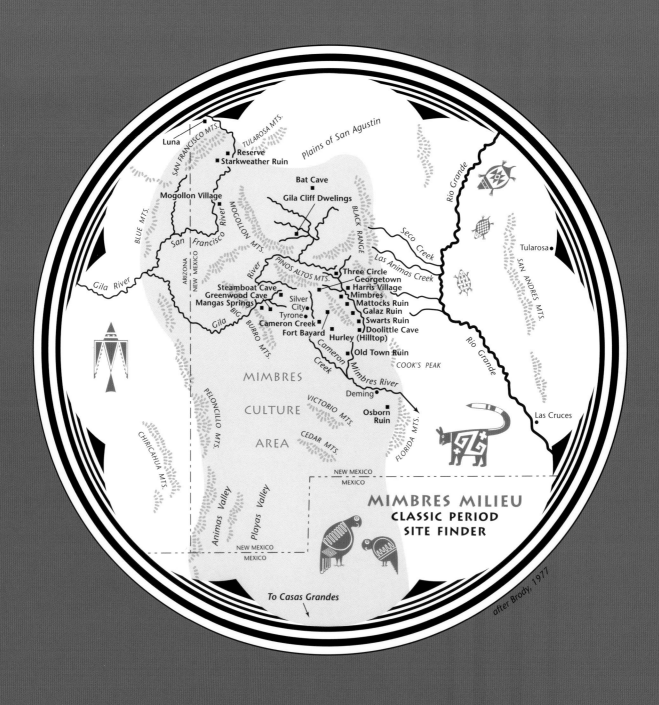

Luna
SAN FRANCISCO MTS.
TULAROSA MTS.
Plains of San Agustin
Reserve
Starkweather Ruin
Rio Grande
Bat Cave
BLUE MTS.
Mogollon Village
Gila Cliff Dwellings
MOGOLLON MTS.
San Francisco River
Mogollon River
BLACK RANGE
Seco Creek
Tularosa
Gila River
ARIZONA
NEW MEXICO
River
PINOS ALTOS MTS.
Las Animas Creek
SAN ANDRES MTS.
Three Circle
Georgetown
Steamboat Cave
Harris Village
Greenwood Cave
Silver
Mimbres
Mangas Springs
City
Mattocks Ruin
Gila
BIG
Tyrone
Galaz Ruin
Rio Grande
Cameron Creek
Swarts Ruin
BURRO
Doolittle Cave
Fort Bayard
Hurley (Hilltop)
MTS.
Cameron
Old Town Ruin
Creek
Mimbres River
COOK'S PEAK
MIMBRES
PELONCILLO MTS.
VICTORIO MTS.
Deming
Las Cruces
CULTURE
Osborn
Ruin
CEDAR MTS.
AREA
FLORIDA MTS.
CHIRICAHUA MTS.
NEW MEXICO
MEXICO

MIMBRES MILIEU
CLASSIC PERIOD
SITE FINDER

Animas Valley
Playas Valley
NEW MEXICO
MEXICO

after Brody, 1977

To Casas Grandes

F irst, it was the river, though barely was it a *río*, that received the name from early Spanish settlers. The river was lined with them: *mimbres*, the Spanish word for willows. The river was named in the seventeenth century, but the natives left in the twelfth, migrating elsewhere in the region because their dry river and mountain valley environment could no longer support their burgeoning numbers. Some went east towards the Rio Grande, others south. Their great ceramic art disappeared with them until the twentieth century, when it was discovered by new settlers, farmers tilling their fields, or ranchers.

The Native American *Mimbreños*, or willow people, were named in the twentieth century, but what they called themselves remains a mystery. They were pit-house and pueblo-dwelling agriculturalists inhabiting the greater region centered on the Mimbres and Gila Rivers in the mountainous region that is now southwestern New Mexico. Artifacts date their early circular pit houses on hilltop sites as early as A.D. 200. They began making decorated pottery around A.D. 750 after moving their homes to low mesas above the river. By A.D. 1000, the beginning of their Classic period, the Mimbreños lived in stone and adobe pueblos, some with hundreds of rooms, along the Mimbres River itself. Population increased, as did the size of the villages, until about A.D. 1150. Mimbres Classic Black-on-white pottery was produced during this one-hundred-and-fifty-year period. Then this remarkable culture seems to have disappeared or have been absorbed into other cultures, leaving only mounds, graves, ruins, and beautifully decorated geometric and figurative pottery as a record of this unique culture. Much of the delightful pottery was unearthed broken or badly damaged and had to be pieced together to appreciate its artistic value. The abandoned ruins remained undiscovered until early in the twentieth century, when settlers began cultivating the mountain valleys and finding the delightful treasures we have today.

Anthropologists, archeologists, and art historians today recognize the unique pottery of the Classic Mimbres culture for its remarkable aesthetic qualities and apparent documentary value in revealing details of a prehistoric people. In contemporary Pueblo culture, pottery making and basketry are predominately practiced by women, and Mimbres pottery may similarly have been the creation of women. In many cases, the artistic sensibility of its creators strikes us as feminine. Besides being potters, the Mimbres women may have woven baskets and perhaps textiles, as well as articles of clothing for winter mountain living—knowledge suggested by their pottery paintings.

At Mimbres Classic-period sites, black-on-white decorated pottery is at most only one-quarter of the total pottery collections. This pottery was painted in black on the white-slipped interiors of hemispheric bowls that were between six and fifteen inches in diameter, using fibers from yucca leaves as brushes. Classic pottery painting illustrated many species of life present in the Mimbres environment, as well as a broad scope of activities in the people's own lives. The earliest period of the black-on-white tradition was characterized by strong, simple designs filling the bowls' interiors. These styles became more elaborate and eventually began including representational images from their environment: birds and fishes; lizards, turtles and frogs; butterflies and beetles; and the many wild animals they hunted. Finally, the Mimbreños recorded their own activities of planting corn; engaging in rituals, games, and celebrations; hunting and fishing; settling differences between clans; trading with their neighbors and teaching their children. Most of our knowledge of their rich lives was pictured by them like snapshots on their pottery.

Figurative paintings of the Mimbreños participating in group activities such as the "Mimbres Corn Planters" design give us a picture of their agricultural activities (pages 134–5). The "Corn Maidens" design may depict their religious relationships with agriculture and their hopes for rain and the best possible weather culminating in a bountiful harvest with an annual festival celebrating and thanking the corn maidens (pages 136–7). Stylized and realistic figurative paintings on pottery giving clues to unique metaphysical beliefs and practices distinguished Classic Mimbres pottery and culture from other southwestern cultures.

W ith the consistent use of the hemispheric bowl for painting, it is believed that the Mimbreños may have found both utilitarian and religious ritual value in this particular ceramic form. The hemispheric bowl had an important food-serving function in daily life as was determined by the signs of regular use on the interiors of many vessels. Hundreds of pots have been found only in fragments in household trash heaps. But the bowl shape also functioned naturally as a funerary or burial icon for their ritual practice of placing inverted bowls over the heads or faces of the deceased in burial. At the grave site the bowl was "killed," or broken, by knocking a hole in the bottom. Perhaps the Mimbres believed this would allow the spirit of the deceased to escape. The dome-shaped upside-down bowl may have symbolized the barrier that separates the physical world from the metaphysical, and the underworld from the zenith above. Still another unusual Mimbres ritual practice involved burying deceased family members under the dirt floors of their pit houses and pueblos, indicating the close familial and spiritual relationships.

Many of the recovered ceramic bowls, both whole and in shards, from the ancient Mimbres ruins may have served both purposes, as a person's food bowl during life and, upon death, as a burial icon, such as the "Jaguar or Panther" bowl design (pages 126–7). Some bowls were designed and painted specifically to honor the deceased upon burial, such as the last bowl design in this volume, "Spirit of a Mimbres Potter" (pages 162–3). Other ritual ceremonies practiced by the Mimbreños may have been represented in the designs of the "Child Naming Ceremony" (pages 130–1); the "Rainmakers" (pages 138–9); and the "Corn Planters" and "Corn Maidens" (pages 134–5 and 136–7).

MIMBRES MENU

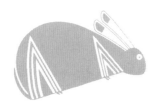

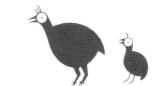

Mimbres food crops, including corn, squash, and beans, created a healthy balance to their varied diet based on hunting and gathering. Wild game available in their environment included rabbits, deer, pronghorn antelopes, mountain sheep, turkeys, Canada geese, a variety of ducks, plovers, sandpipers, phalaropes, quail, and other small birds, and several species of fish, including trout, catfish, and other edible varieties.

Probably their most common game foods were rabbits, deer, turkeys, geese, ducks, and quail. This is not to say that all that the Mimbreños painted was also part of their menu. According to Hopi cosmology, cranes are considered protectors of the ancestors. If the Mimbres shared this religious respect for cranes, it is questionable whether this bird would have been part of their diet. Alternatively, the Mimbres pottery painters' humorous exaggeration of the long necks of cranes and herons and their voracious appetites for fish make one wonder about the potters'religious respect for cranes or for their ancestors. The Mimbreños must have dearly loved rabbits and quail, based on the many delightfully sensitive bowl paintings that have been recovered. They may have illustrated respect for certain dangerous animals by painting symbols of lightning on their bodies. Strangely, they painted designs suggesting abstract butterflies on the shells of turtles. Perhaps while sitting by a stream they happened to see a butterfly land on a motionless turtle's carapace. The Mimbres women observed nature with very creative eyes and were extremely talented in illustrating what they observed.

Raising food became critical in importance in the twelfth century, as the Mimbres population increased and the supply of game in the area diminished. It is also believed that droughts plagued their corn, bean, and squash crops between A.D.1130 and A.D.1150 when they slowly moved in search of richer lands. The Anasazi culture in Chaco Canyon dispersed at about the same time. This apparent migration of two great Native American cultures is one of the greatest unsolved mysteries of prehistoric times. Did they disperse for lack of food, or was outside force applied by other cultures? Today's anthropologists and archaeologists are exerting great efforts towards solving this powerful mystery.

The Mimbres culture was a prehistoric, two-hundred-year anomalous outpost of enlightenment, influenced, perhaps, by the Mesoamerican whirlwinds of advanced cultures during the first and early second millennium A.D. The Mesoamerican influence appears to have been limited because the Mimbreños were far to the northwest and isolated by mountains. The Mimbreños lived in pre-Columbian times, before the American continents were known to Europeans. Their word-of-mouth history has not survived, of course, but they were able to give us their "illustrated history" on their creatively painted pottery, unearthed one thousand years later. Knowledge of those times in the Americas is dependent now on ruins, graves, and artifacts as analyzed by anthropologists and art historians for the very existence and reality of its peoples and their cultures. Evidence has been found in Mimbres sites of exotic trade goods obtained from neighbors to the south: scarlet macaws and macaw feathers originating in the tropics, shell beads and ornaments from the Gulf of California, and a small number of copper bells. Pre-Columbian times present us with a great many vast puzzles, still unsolved, on the American continents. These puzzles are deeply involved with cultural relationships and influences among the native peoples whose ancestors originated in Asia in antiquity and migrated across the Bering Strait. The arrival of the Spanish in Mesoamerica early in the sixteenth century led to the military destruction of the Aztec Empire and the burning of precious Maya codices. Works of art were demolished that could have given us much greater knowledge and understanding of the pre-Columbian civilizations that may have had contact with the Mimbres.

WHENCE CAME THE WHIRLWINDS?

Both the Mayas and Toltecs practiced bloody public human sacrifice of their people and captured enemies to appease the gods, causing widespread, obsessive fear of death. Losers of their ball games had their hearts cut out in bloody sacrifice. Circa A.D. 900, as the Maya culture declined, the Toltecs adopted much of the Maya pantheon. In Nahuatl, language of the Aztecs, the word *pochteca* referred to elite families with warrior and merchant functions designated by their ruler to assemble the necessary party to personally explore the lands of Northern Mexico and the American Southwest in search of trade and natural resources. Their influence may have been felt as far north as Chaco Canyon of the Anasazi, into the Hohokam area of present-day Arizona, and throughout the Mexican Isthmus of Tehuantepec. Anthropologists have written about the possible presence of Toltec pochtecas at Chaco Canyon between A.D. 1060 and A.D. 1200, and many reject the idea. However, it continues to be controversial. We find that Mimbres pottery designs seem to indicate adoption of a peaceful rather than warlike pantheon.

Evidence has been found at Chaco Canyon of trade relations, but the exact nature of that association has not been determined. It is possible that the Toltecs taught their building skills to the Anasazi in exchange for turquoise from the Cerrillos Hills south of present-day Santa Fe. A large quantity of Cerrillos turquoise was transported to the Toltec city of Tula north of the Valley of Mexico for crafting jewelry. Toltec merchants influenced the cultures of Northern Mexico as well as Guatemala and the Yucatan. Toltec influence on the Anasazi may have been aggressively intimidating, with human sacrifice, beheading, and perhaps cannibalism for purposes of control. Some people believe the pochteca brought the Mimbres the cult of Quetzalcoatl and the Hero Twins of the *Popol Vuh*, the famous Quiche Maya epic.

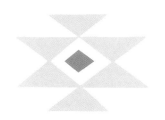

Τhis book brings historical attention to the millennium anniversary of the Classic Mimbres culture, A.D. 1000–1150, and, in particular, to the Mimbreños' ceramic arts, which so graphically illustrate their cultural activities, cosmology, religion, and daily lives, including the wonderful variety of creatures common to their environment. In bringing attention to this one-hundred-and-fifty-year period in the pre-Columbian era we are aware of two very important and intriguing facts, first, that the millennium anniversary extends for one hundred and fifty years beyond A.D. 2000, and second, that the Classic Mimbres culture was approximately contemporary in time with Classic periods of four other important Native American cultures. In addition to the Mogollon culture, of which the Mimbres is a part, these include the Hohokam culture in Arizona; the Anasazi culture centered in the Chaco Canyon area of New Mexico; and the Toltec culture of warriors, merchants, and craftspeople centered on the city of Tula, north of the Valley of Mexico. All of these cultures deteriorated, collapsed, or migrated around the year A.D. 1200.

MIMBRES CLASSIC
POTTERY DESIGNS

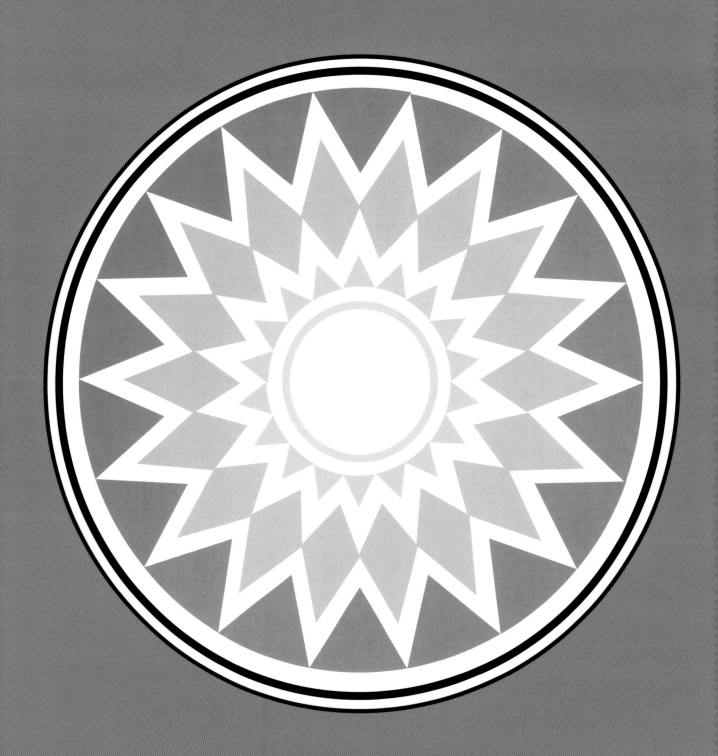

This Mimbres geometric bowl design, painted in black-on-white in a hemispheric bowl at the beginning of the second millennium, was restyled in color as a conceptual expression of our time to celebrate the start of our third millennium. A motif we identify as the sun, a dominant element in the daily lives of the Mimbreños, became an often-painted design in their pottery bowls. Whether the Mimbreños honored the sun as their foremost deity is one of their mysteries, but their solar bowl paintings and the sun gods in the pantheons of ancient Mesoamerica, in the Toltec culture, and in the post-Mimbres Pueblo pantheons of North America indicate they may have.

The Toltecs were warriors, merchants, and craftsmen who lived north of the Valley of Mexico and were contemporaries of the Mimbreños. Their sun god is thought to have had the same name as the sun god of the later Aztecs, Tonatiuh. The people of the great Maya culture honored their sun gods, Itzamna, and his son, Kinich Ahau, symbolized by a two-headed sky-serpent. They were believed to be "rulers of the heavens," "lords of day and night, earth, and sky," "creators of human life," "patrons of science and learning," and "inventors of books and writing." The sun has always been the primary god, the father, in the pantheons of historic and contemporary Pueblo Indians. At Zuni Pueblo and Acoma Pueblo the sun god always existed. As the sun rises each day, the Zunis stand outside their doors, throwing cornmeal as a greeting to their "father sun." The sun is the presiding god of the seasons. Today, many Pueblo people present their newborn child to the sun on either the fourth or the eighth day of his or her life, holding the naked child up to its rays at sunrise.

SOLAR SYMBOL,
SUN GOD,
LIGHT AND LIFE

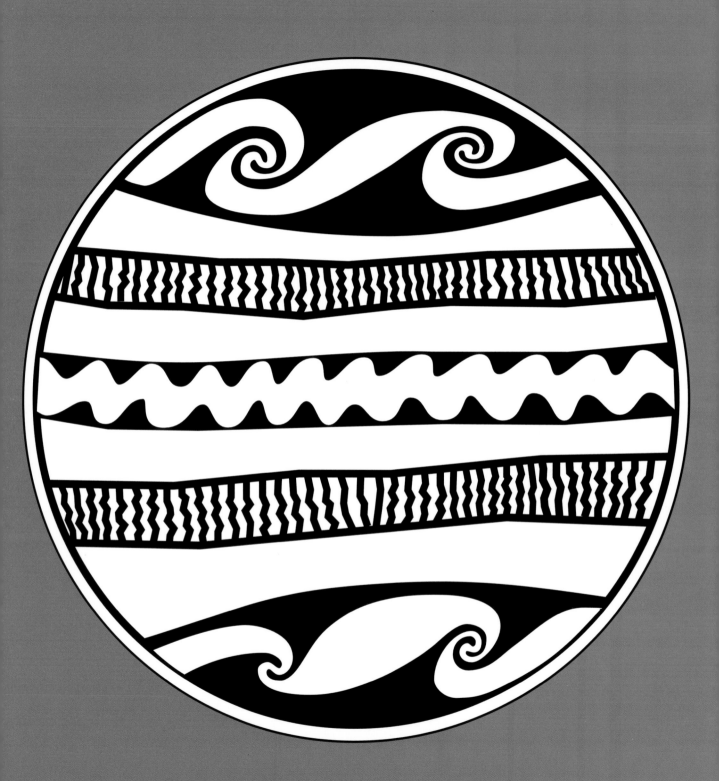

T his beautiful Mimbres design, created in the boldface style around A.D. 850, may depict, in its rich symbolism, the environmental elements of earth, sky, and waters. Striated landmasses, swirling clouds, and wavy waters are all shown in horizontal bars painted inside a ceramic bowl in black-on-white glaze. When converted to two-dimensional graphics as shown here, the design gives the impression that the Mimbreños were knowledgeable that the earth is a globe in space. Regardless of their apparent curiosity about subjects astronomical and environmental, it seems unlikely that they had such knowledge. As shown in the following geometric designs, the Mimbreños' interest in their environment was very broad and included the sun, moon, stars, clouds, lightning, and rain. They also were absorbed in agriculture, hunting for food, birds, fishes, reptiles, insects, and animals. Family, the arts, and peaceful trade relations among themselves and other people apparently were of interest to the Mimbres, judging by the pottery.

In our analysis of Mimbres painted pottery designs, it seems clear that the Mimbreños may have adopted much of the ancient religious pantheons of Mesoamerican cultures and may have had knowledge of stories from the *Popol Vuh*, the so-called Maya Bible, describing the Mayas' concept of the creation of the world and all of its creatures. The Mimbreños may have revered some of the mythical gods whose stories were written and illustrated in that amazing book. This design reveals an interest in creation and cosmology. The important questions of if, how, and by whom religious, cosmological, and cultural knowledge may have been conveyed to Mimbres people in the southwestern U.S. is the ongoing subject of discussion among anthropologists. Was this a broad spectrum of knowledge conveyed to the Mimbres by direct contact with Toltec pochtecas from Tula in faraway Mesoamerica or through cultural diffusion?

EARTH, SKY, AND WATERS

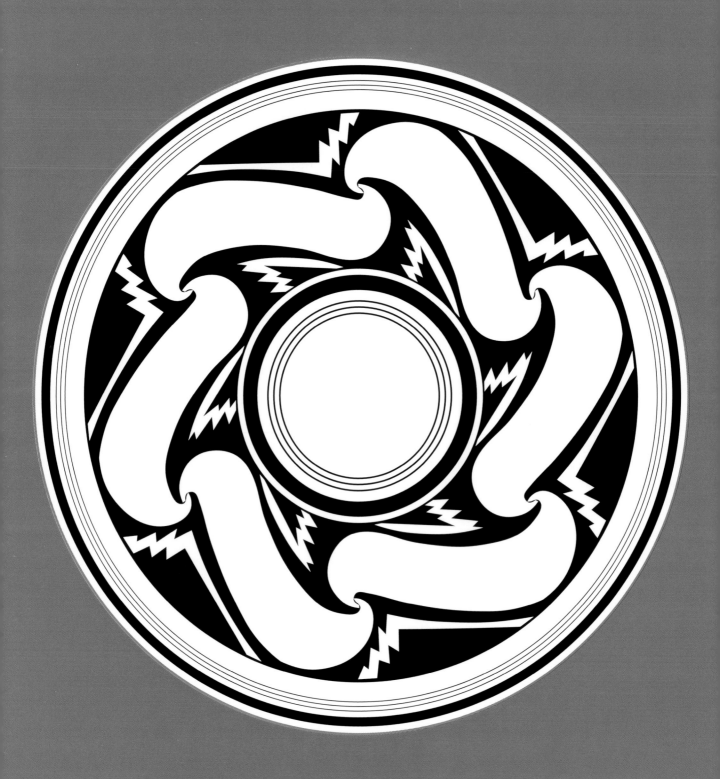

T he Mimbres pottery painters had a remarkable talent for creating pictorial snapshots of the elements in their environment on pottery. And it's likely that they assigned gods to many of those elements of nature, such as the sun, moon, and stars; lightning, thunder, and clouds; insects, birds, fish, and animals. This helped the Mimbres comprehend and control their world, just as other human beings have throughout time. But there was something unique about the Mimbreños. As a peaceful people, they seem to have developed respect for everything around them, including each other, and especially the specific elements that made their food crops thrive, namely, sunshine, clouds, lightning, and rain. These elements were so important to them that they often included symbols of them in their food bowl paintings. Note the many jagged and stepped lines, swirling clouds, whirlwinds, and whirlpool spirals in these bowl designs. Additionally, and possibly because of their assignment of special powers to certain creatures and the well-known natural danger of lightning strikes in their mountainous milieu, they often used a lightning motif as a simultaneous symbol of power and danger in paintings of the creatures they believed had special powers that could be a hazard to their people. You will observe throughout this book an application of lightning symbols of power to some species of creatures.

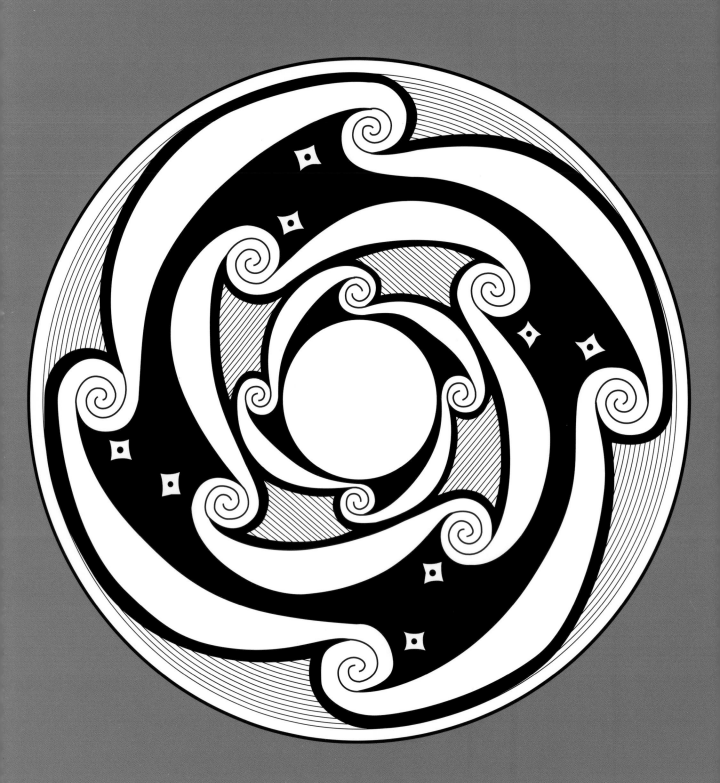

F ollowing a turbulent afternoon of lightning, thunder, and blowing rain, the Mimbreños may have enjoyed a pleasantly relaxing evening in their mountain valley with a sky of feathery-white, whirling clouds that divided, allowing bright stars, including Venus, to show through in the evening and early morning, while the whirlwinds found their way down the hillsides and along the river. The climate was so delightful that they painted a variety of pictures of it inside many of their ceramic bowls. One example may be this outstanding design, found in the late 1920s in what is called the Swarts Ruin along the middle Mimbres River valley by archaeologists from the Peabody Museum of Archaeology and Ethnology at Harvard University in Cambridge, Massachusetts.

The large, outlined star symbol, we believe, represents both Venus, the morning star, and Quetzalcoatl, the feathered serpent god. Quetzalcoatl is depicted as a rattlesnake or *coatl* in the language of the Aztecs, wearing as a collar the brilliant blue-green feathers of the quetzal, a Central American bird. The Quiche Maya worshipped such a deity as their creator. The feathered serpent was one of the most powerful of gods in the Valley of Mexico and Guatemala during much of the first millennium A.D. Among the Toltecs, a man appeared named Topiltzin who adopted the persona and symbols of Quetzalcoatl and promoted himself as their god and ruler. The Toltecs became a merchant and warrior culture, exporting their religion and material culture throughout Mexico and northwards. It may be that the Toltecs influenced the contemporaneous Mimbreños' lives, culture, and religion to some degree, as appears to be indicated in many bowl designs.

In this bowl design, we believe spirals were used by the Mimbreños to picture real whirlwinds. The single spiral, a fertility symbol the world over, was also the symbol of a mythical Hopi spirit, called Bo-ho-ho, whose breath produced whirlwinds, cyclones, and whirlpools in water and the very breath of the Hopi people. The Zunis mapped the travels of their people with double and triple spirals in their long search for their "middle place" home. Southwestern Native Americans often planted their corn in a spiral, starting in the center of their fields.

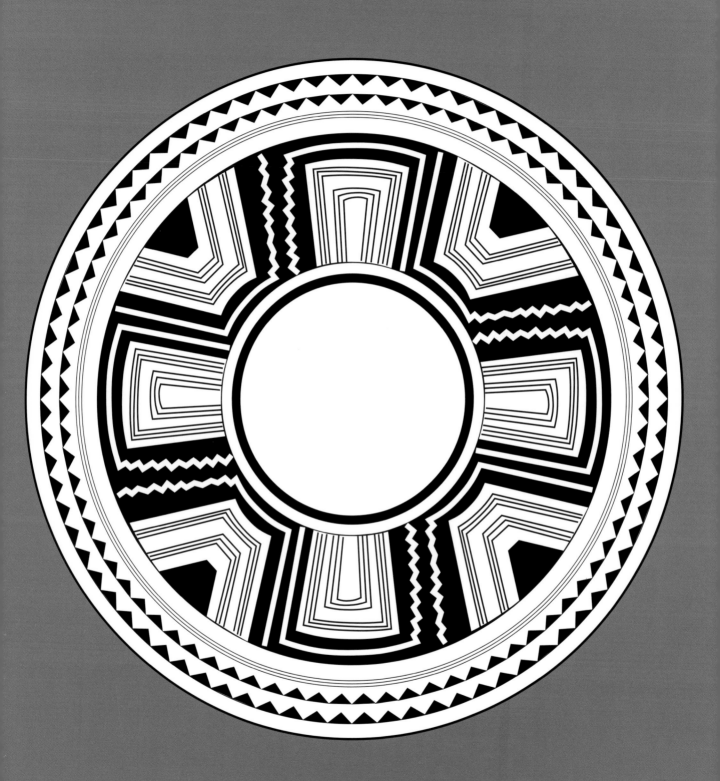

When the first evidence of a daughter's puberty occurs, Pueblo Indian parents celebrate their daughter's transition to adulthood with friends. The bowl at left was unearthed intact from a Mimbres site. The design resembles a Maltese cross. According to Alexander M. Stephen, who lived with the Hopi Indians for fourteen years in the late nineteenth century researching their language and customs, this is a virgin emblem derived from the hairstyle worn by Hopi maidens until marriage. It may be possible that both the Hopi hairstyle and the emblem were inherited or derived from the Mimbreños. We believe that Mimbres parents celebrated their daughters' coming of age in similar manner, possibly with this beautiful, specially designed ceremonial bowl bearing a unique emblem. However, the design from this Mimbres bowl is the only evidence available, so the significance of a young woman's coming to adulthood to the Mimbres and the nature of their celebrations cannot be known.

VIRGIN
EMBLEM

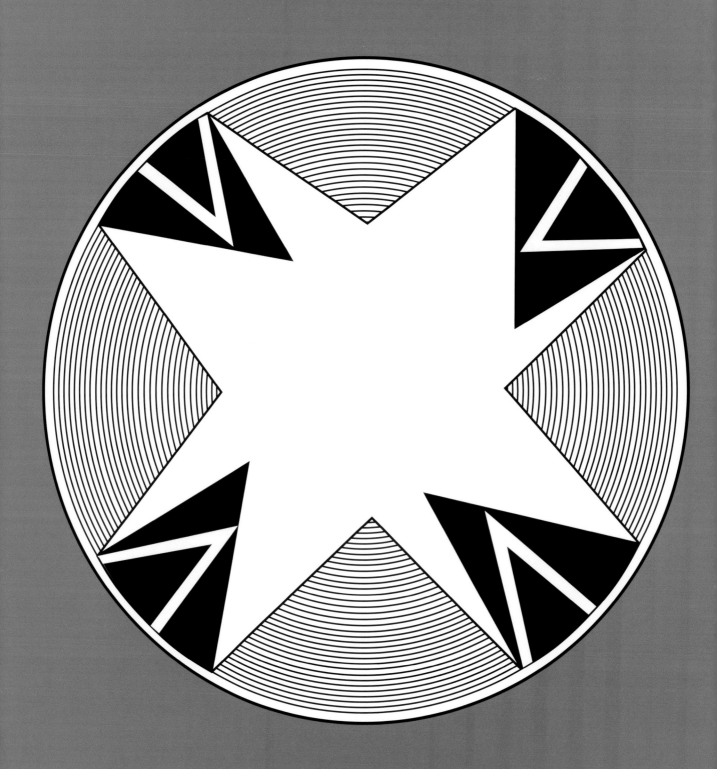

Discovered intact in the Swarts Ruin by archaeologists from the Peabody Museum in the late 1920s, this most creative of all cruciform bowl designs provokes a myriad of questions in our minds today. Why is it so simple, so modern in style compared to the previous emblem and other Mimbres cross or star designs? Actually, in this orientation, it resembles a Christian St. Andrew's cross. In another orientation, it might even be considered a very creative form of the Toltec cross representing Quetzalcoatl in his star form (pages 17 and 21). In one historic Pueblo pantheon, a deity is named Co-tok-i-numg-wuh, meaning "star god." Do the black and white triangles on the four tips of the cross have a symbolic meaning? In some Mesoamerican cultures, triangles were symbols of fertility. Is it possible that this cross represents the four horizontal directions in the Mimbres cosmos (pages 22–3)? The four points of this cross could be said to form four points of a square, flat world and the median lines between them to indicate the four horizontal directions, north, east, south, and west, by our compass today. Finally, how was the Mimbres artist able to precisely paint so many concentric circles, so evenly spaced by hand, to texture a background? Might she have had some kind of wheel on which to rotate the bowl while holding the yucca fiber brush still, in a stable position against the interior wall?

SKY GOD
SYMBOL

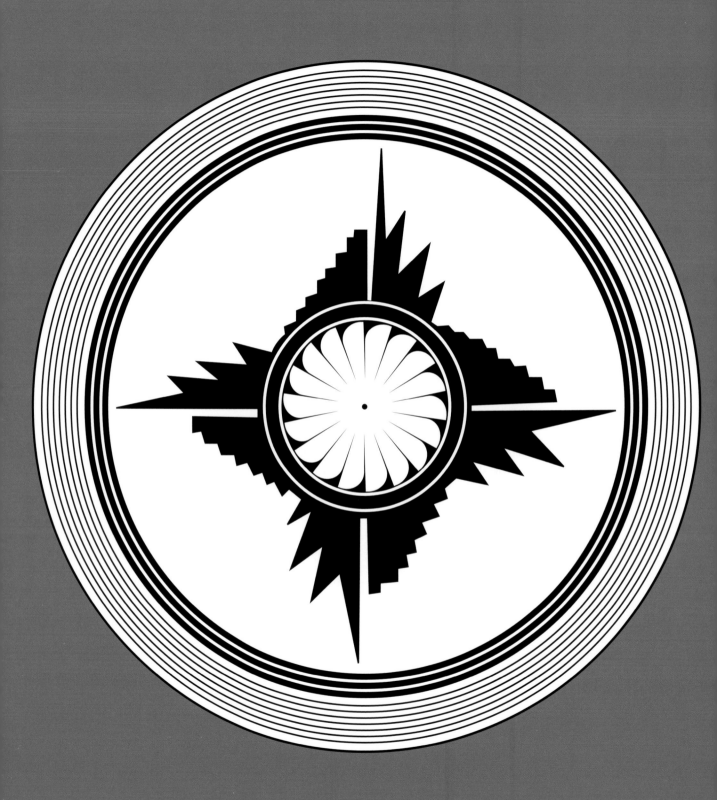

It is possible that the Mimbres cosmology was drawn from many earlier cultures of Mesoamerica. It is also similar, in some ways, to concepts of today's Pueblo Indians, notably Hopis and Zunis, probably because Mesoamerican cultures exerted a broad influence upon the ancestors of most of the Pueblos. The Mimbreños saw their universe as having four horizontal directions: North, East, South, and West, plus up (the zenith), down (the underworld), and the "middle place," their home. To the Maya the zenith was multilayered, with gods or spirits for each layer. The underworld was ruled by a god who sacrificed both gods and men by decapitation, and was the inevitable destination of all people, until their spirits could work their way up the layers of the zenith. The Maya believed the earth was flat, and when the sun, moon, and stars set below the horizon they passed through the underworld until the sun rose again the next day. Both the Maya, possible ancestors, and the Hopi, unlikely descendants, of the Mimbreños, assigned colors to elements of their universe. To the Maya, north was white; east, red; south, yellow; west, black; and the "middle place," green. The Hopi reversed the colors of east and south and made west blue, while assigning black to the sky and red-brown to the earth. The color symbolism adopted by the Mimbreños is unknown, though it was most likely limited only by the ceramic colors they could mix from iron (black, brown, red) or copper (blue, green) and vegetable pigments (yellow and orange). Today, we refer to a design like this as a "compass rose." To the Mimbreños, it may have been a picture of their universe, with a concentric fan of feathers, representing themselves in their home, surrounded by the life energy and action of lightning, expressing their pride as a people. The many concentric circles in the border of their design were hand-painted, strikingly close to the perfection of our computer-generated rendering. How they did it, unless they finally invented the potter's wheel, will remain their secret.

THE MIMBRES
UNIVERSE

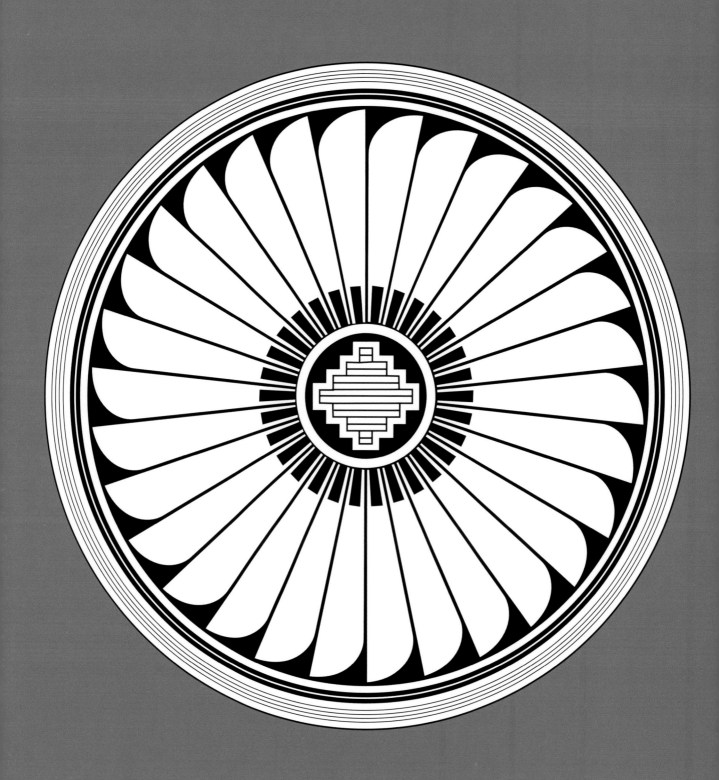

When J. Walter Fewkes, head of the Bureau of American Ethnology of the Smithsonian Institution, exhibited this bowl along with other Mimbres pottery, it was widely published in the Southwest. The design inspired and revitalized Pueblo and Navajo artisans, who copied its beauty and symbolism in their ceramics and silver, turning it into an effective symbol for southwestern Native American arts. But, as seen in the previous bowl design, it may have been created by Mimbreños as a cultural icon representing themselves. Now, it has been so widely proliferated in recently produced Indian art that its creation a millennium ago has almost been forgotten. Its radiant rotary fan of feathers now beautifies San Ildefonso and Acoma pottery, and Hopi and Navajo silver buckles. The center design element, a double stepped pyramid, is known as a "shrine" in the Pueblo pantheon and is said to represent the home of the Pueblo people and their multiple gods.

A SYMBOL
OF THE
MIMBRES

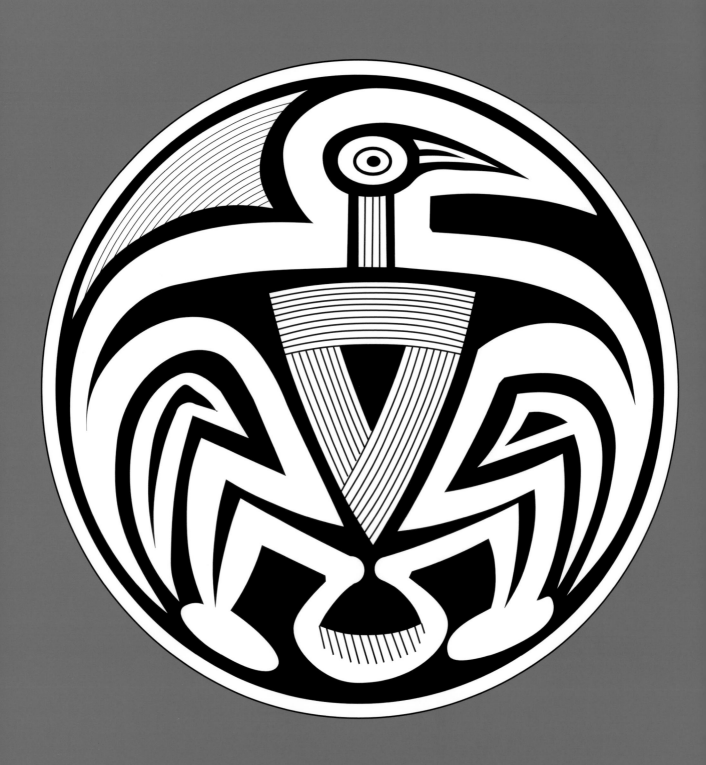

O ne of the earliest Mimbres geometric designs adopting a bird form, possibly a crane, as its subject, this powerful, borderless, boldface bird truly captures one's attention. It is a "killed" mortuary bowl, so the subject may be a highly stylized, monumental depiction of a crane, because in the Mimbres mythology the crane may have been respected as the protector of ancestors as it is among historic Pueblo societies. Native Americans in many historic and prehistoric periods exhibited great respect for all species of birds, attributing special powers and spiritual characteristics to each. They developed spiritual attachments to bird feathers as fetishes and for use in prayers and supplications to their deities and spirits. This particularly remarkable development of the bird form into abstract positive-negative geometry required the skill and experience of a very creative artist. The formal monumentality of the bird's posture suggests that the deceased subject might have been a respected leader, a shaman or holy man, a clan member, an important person of stature. Neither the deceased nor the creative artist will ever be known to us.

BIRD

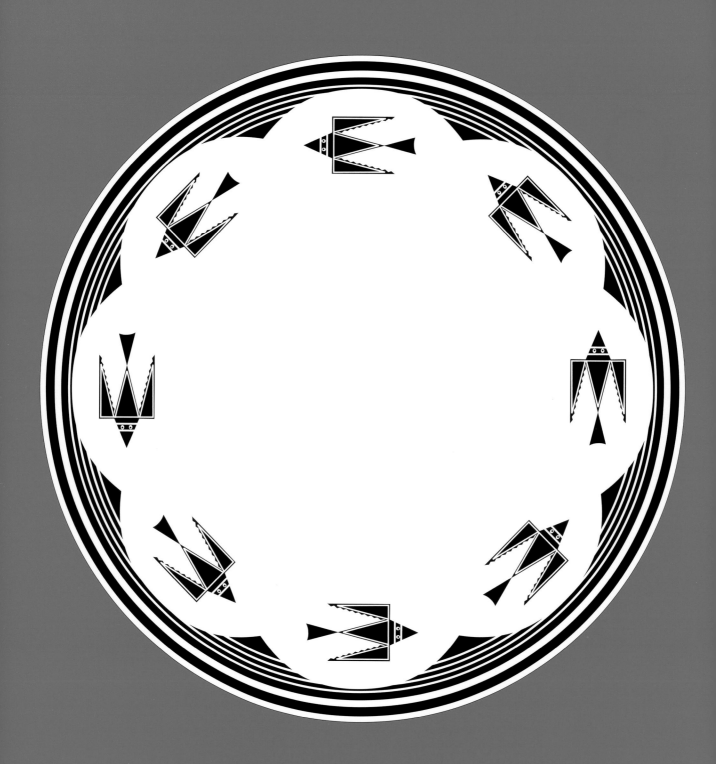

T he Mimbres pottery painters also included living creatures in their bowl designs, for example, birds and fish. The bowl design shown here was derived from a single shard only, shown below, which contained a complete design element that was obviously repeated multiple times, most likely eight, by measurements and typical Mimbres bowl design divisions, to make a complete border design of geometric birds in flight. This is a unique design, indeed! The birds are flying beak-to-tail, counterclockwise around the bowl against what appears to be a large white cloud filling the center. The Mimbreño artists developed an unbelievably precise skill of painting concentric multicircle borders on bowls.

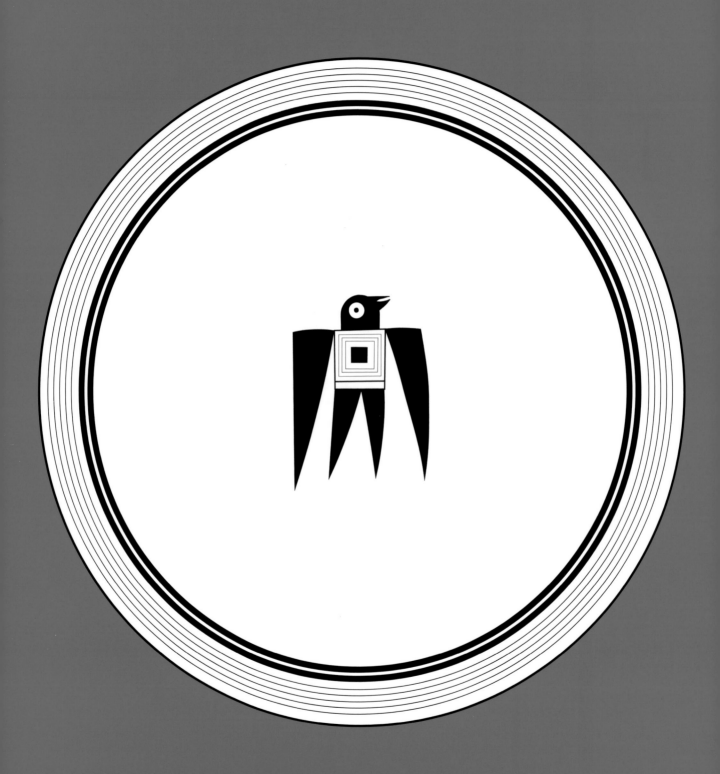

S tudying this clean, simple, delightful Mimbres bowl design, one would conclude that it is of the Classic period. The swallow is definitively in a geometric style, and beautifully delineated and styled. The linear border rings are typical of Classic period designs, and the very talented artist has truly captured one of the commonly observed postures in the flight of the swallow, as well. The concentric rectangles on the breast of the swallow form a symbol that seems to us to have multiple meanings. Some anthropologists say that it is a symbol of the vastness and the infinity of the sky against which the bird is rising vertically. But what is its meaning when it is applied to the bodies of scorpions (pages 100–1) or to a mountain goat (pages 112–3)? The Mimbreño artists often applied a similar design to other birds in the form of a diamond (pages 56, 58). Also, there is the form called a shrine, separate from the cranes, in the design, possibly borrowed from the markings of the diamondback rattlesnake, leaving us with a great many questions and very few answers (see "Shrine of the Crane Spirit," pages 60–1).

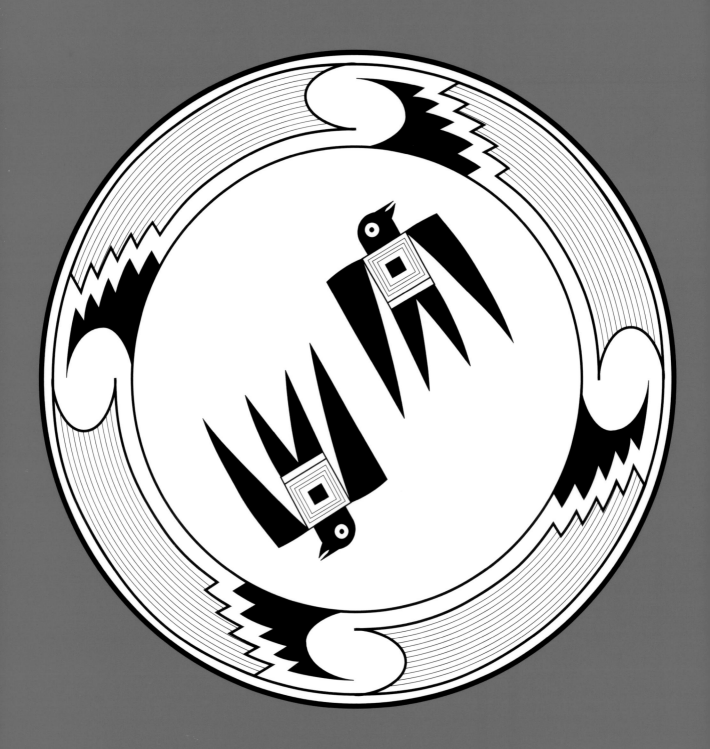

This beautiful design was adapted and assembled from these two Mimbres bowl designs, one bearing the border only, with clouds and lightning, and the other with one swallow in the center and a very simple border (see "Single Swallow," pages 30–1). The illustrators of this book doubled the single swallow and placed it in the center of the clouds and lightning border. All design elements in this adaptation, however, were created by the Mimbreño artists. The species of geometric birds in the previous "Bird Border" (pages 28–9) cannot be identified, but the birds in this bowl must be swallows, the only inland bird with that deep-split tail. Concentric squares or diamonds on the breasts or sides of Mimbres bird designs were common, also, to many of their other creature designs. Is it possible that these are different forms of what we consider a shrine symbol in Pueblo religious ritual? (See "Shrine of the Crane Spirit," pages 60–1). Or were they only targets for Mimbreño bow and arrows?

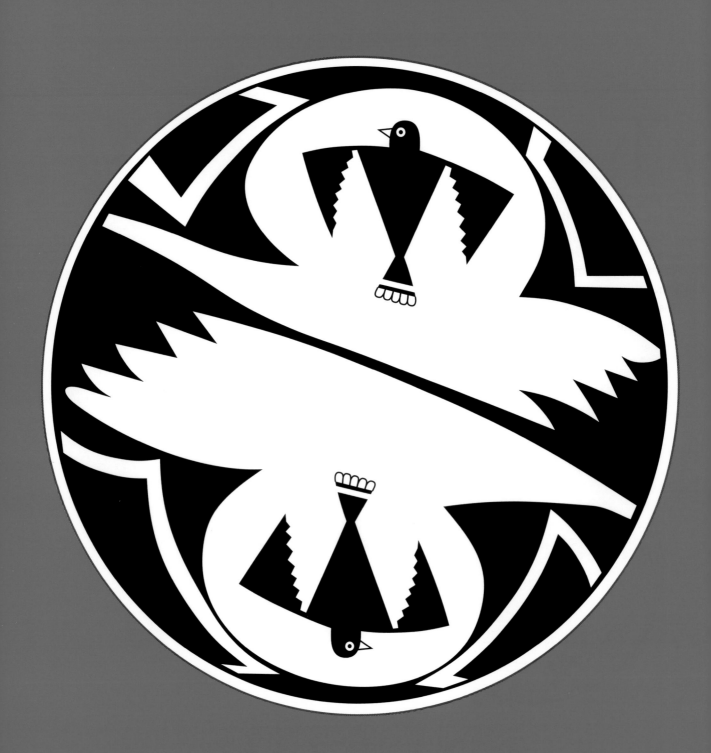

A remarkable reverse design of a black bird on a white egg and a wing on black background, painted in black-on-white glaze, this painting shows that the Mimbreños thoroughly mastered the reverse-painting technique. While the bird design is severely geometric, the white egg and wing show an understanding of realism characteristic of the Classic period. Though the bracket-like objects tend to contain the realistic subjects, the painting is borderless, a treatment common to pre-Classic painting. This inspiring design bears a strong spiritual quality while, at the same time, conveying both the transitional nature of bird life from egg, to bird, to egg, and the transition from geometric to realistic art in their hemispheric pottery paintings.

BIRD, EGG, AND WING

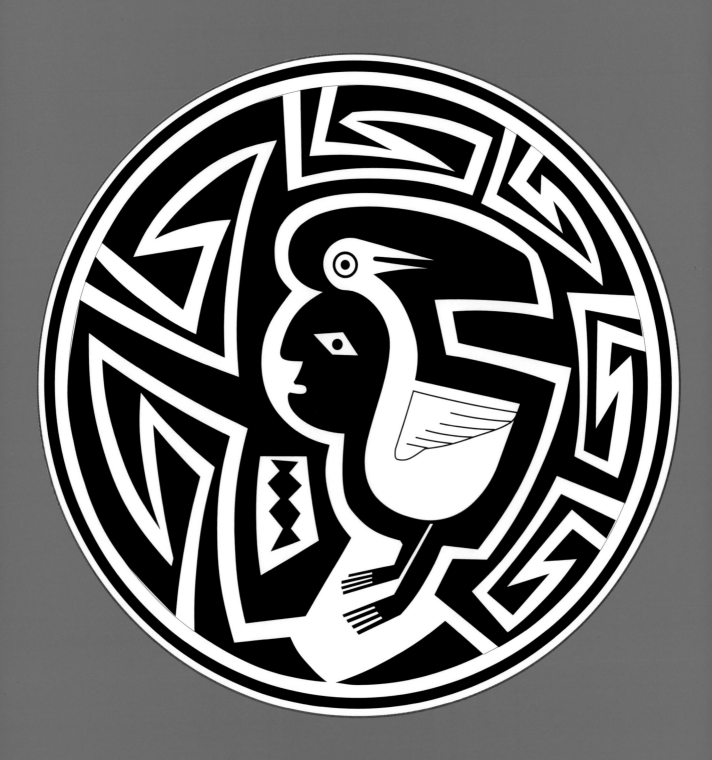

P ossibly the most exciting and challenging of all Mimbres pottery designs, this one nearly always gets the same response when first seen: "Picasso!" they cry, which says something about its style. The symbolic lightning energy surrounding the graphically united black and white figures effectively completes the concept. But explaining its meaning is quite another thing. Since this bowl was placed over the head of a deceased person in burial, perhaps contemporary Pueblo religion might begin to explain the complex statement in this disarmingly beautiful work. According to modern Pueblo beliefs, human beings are one with all living creatures; man embodies both human and animal natures or spirits; and the crane is the protector of ancestors in the afterlife. Of course, there is no way that anthropologists can be certain that the Mimbreños espoused elements of contemporary Pueblo religions.

One might also assume that peoples of Mesoamerica, both before and after the Mimbres Classic period, shared beliefs similar to those of the Mimbreños. The facial structure of the human head in this complex design, particularly the forehead and nose, bear a resemblance to images of the Maya people and to their descendants in Mexico and Guatemala today. Other designs may also suggest Mayan profiles (see "Corn Planters," pages 134–5). Is it possible that descendants of the Maya lived among the Mimbreños during the Classic period?

MAN/CRANE

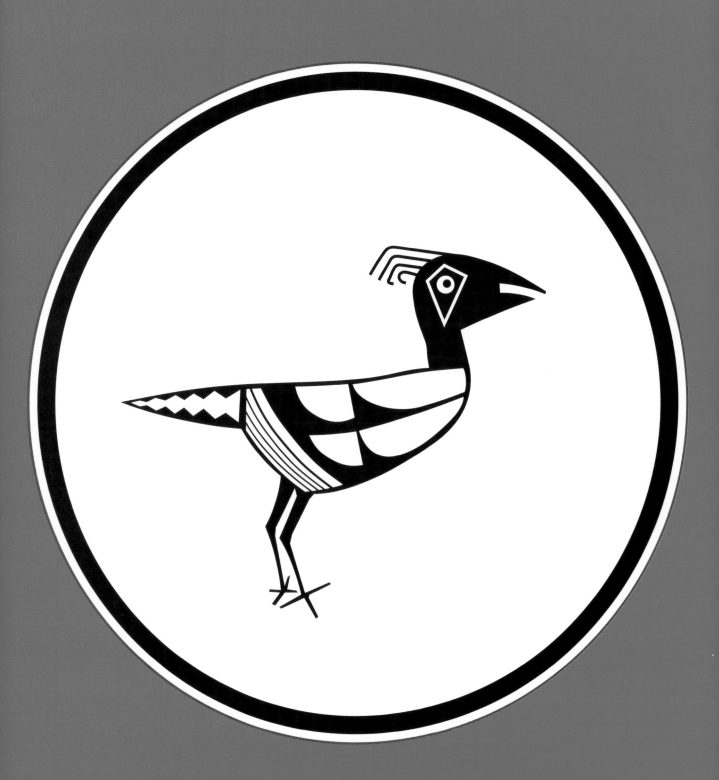

The famous bird that can fly but prefers to run or walk was seldom illustrated by the Mimbreños on their hemispheric black-on-white pottery. In this bowl, his color is red-on-white because of too much oxygen in firing. The Mimbreños used mostly an iron-based paint, which, when fired with the right amount of oxygen, gave them a rich black. However, too much oxygen often produced a rust-red color. Many designs produced only red-on-white pottery when the oxygen content was not properly controlled. Except for color, this rather geometric image is quite accurate, and we think it is almost realistic. Surprisingly, J. Walter Fewkes identified this bird as a quail, even though he had lived with Hopi Indians in an environment that included roadrunners. The roadrunner is a large, fast-running bird, actually, a ground-dwelling cuckoo, about the size of a crow, which captures and eats lizards, snakes, worms, caterpillars, and great amounts of grasshoppers in season. Its plus-shaped footprint makes it hard to track. The female roadrunner nests in dense brush. Its image in a Mimbres hemispheric bowl used for burial may have represented it as guardian of the ancestors. To the Zuni Indians it represents a symbol of war.

ROADRUNNER

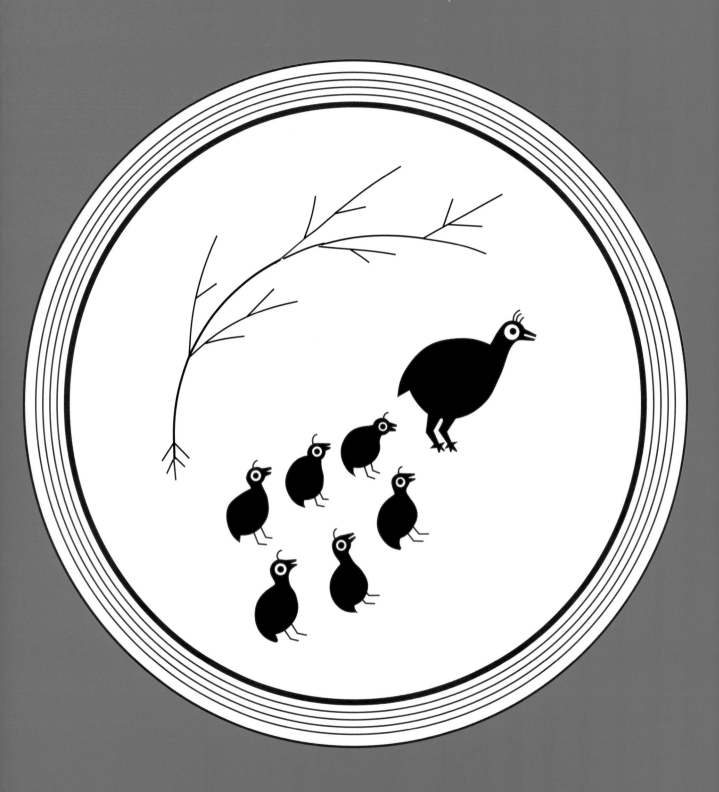

Threw Mimbres people hunted and feasted on several species of quail, a member of the Galliform family. Other Galliforms are chickens, prairie chickens, pheasants, bobwhite, and grouse. Species common to their environment today are the Scaled quail, Gambel's quail, and Harlequin quail. It is impossible to identify the species shown here, since the little creatures are shown in silhouette without typical markings. Quail gather in groups called bevies, often assembling in tight circles on the ground, with tails centered and heads facing outward, allowing them to suddenly fly in all directions as a confusing, protective measure against predators. This design, with the bent twig or bush under which, typically, the quail family is hiding, is one of the very few Mimbres designs that include any element of the local landscape. It is truly a mystery why a people so aware and focused on all the animals around them would so rarely include the flora of their beautiful mountain valleys or the trees, rivers, and mountains in their works of art.

While quail may have been an occasional food source for them, the Mimbres also appear to have been quite attached to the little birds, illustrating them often, both singly and as families, on their Classic black-on-white pottery. The Mimbreños appear to have developed a natural connection between birds, their feathers, and the spirit world. And their spirit world may have involved a cult of ancestor worship. This very sensitively rendered design has a character similar to many Japanese prints and is possibly the most universally admired, today, of all the thousands of recovered pieces of Mimbres painted pottery.

QUAIL FAMILY

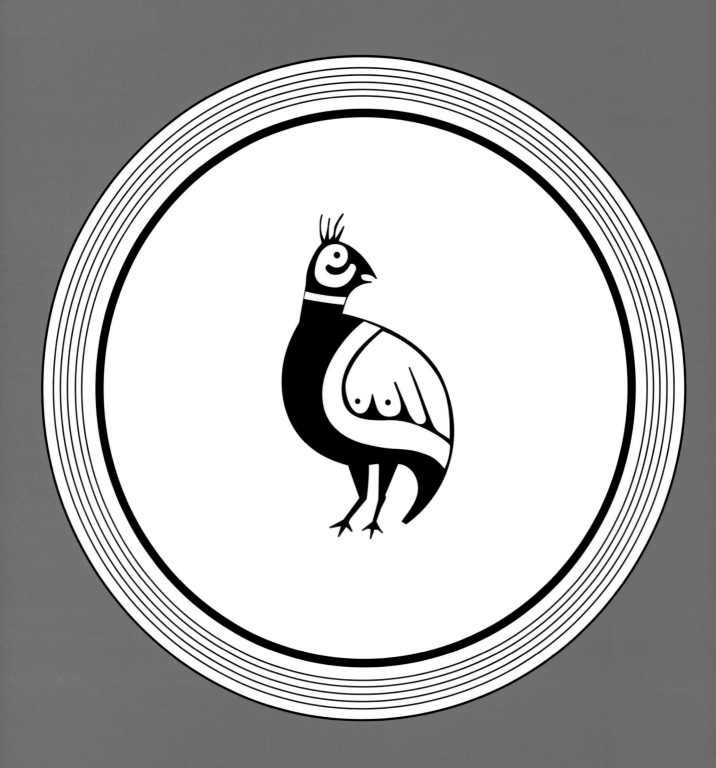

The elegant quail design has markings that are a little different from the Harlequin quail, common in today's Mimbres environment. Certainly, they both have the dark brown breast and head with topknot markings, plus the readily identifiable stance, but the wing and back markings vary. Is it not possible that quail markings have mutated over a period of a thousand years in the same environment and that this is an extinct variety of quail? It is improbable. More likely, the Mimbres painter mixed in details of other birds as an expression of the artist's beguiling and creative sense of humor, or simply to play with abstract, decorative details. Quite a number of pieces of Mimbres painted pottery mix parts of two, even three, different animals to make their own creatures for reasons completely unknown to us.

HARLEQUIN
QUAIL

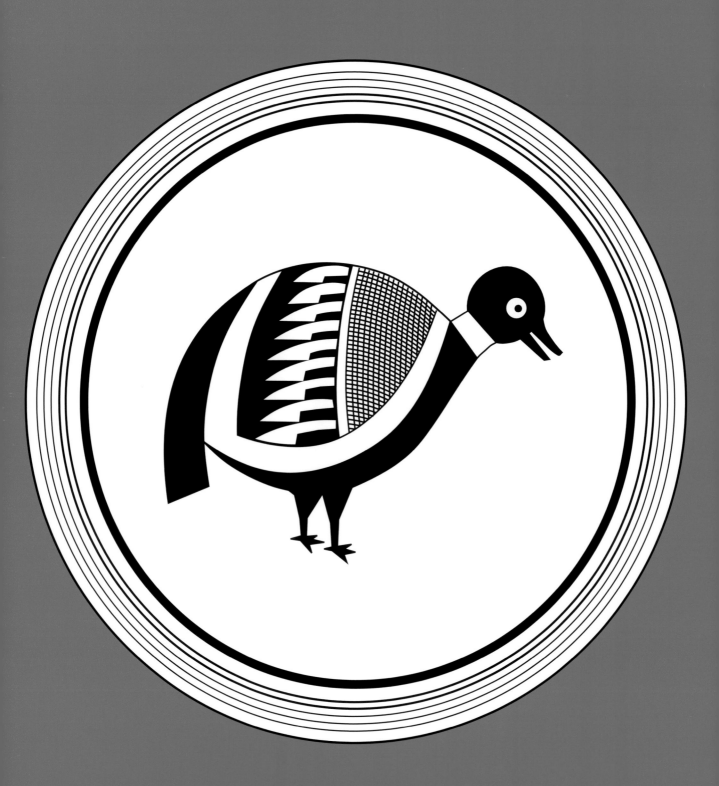

This Mimbres duck has all of the characteristic markings of the mallard, except for the white breast of today's widely known mallard. So are we dealing again with a mystery? Sometimes, when you are making a black drawing on a white surface, it is more effective to have a solid black area form the outline of the subject rather than just a thin line. Mallards, today, are the most common duck on the North American continent and in Mexico. Were they that common a millennium ago? How accurate is this rendering? Good questions, but we may never know the answers. These are all the kinds of challenging mysteries that archaeologists and art historians face daily.

MALLARD

DUCK

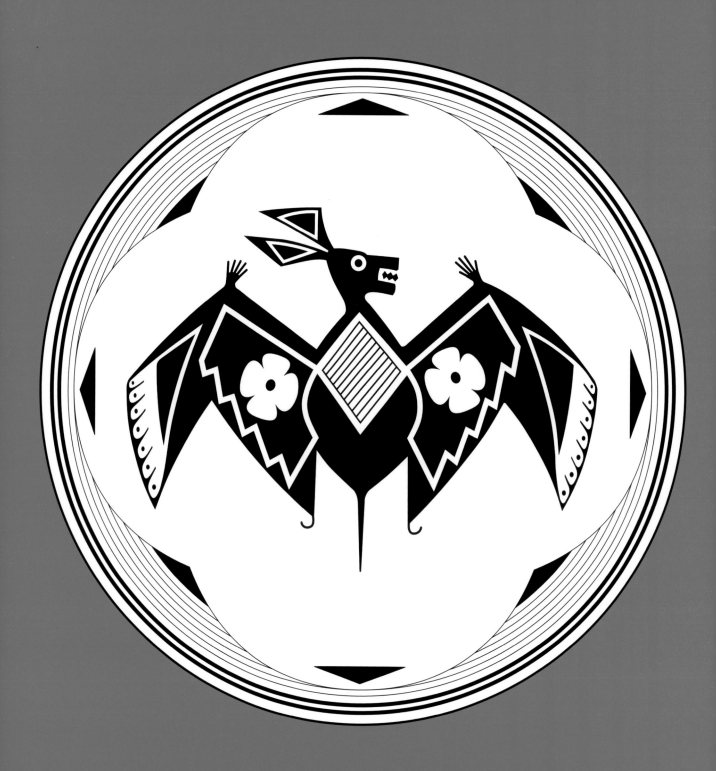

It may be that the Mimbreños believed the bat was a bird simply because it was such a magnificent flyer in the evening and night sky. Their obviously detailed knowledge of the life in their environment, however, suggests that they surely knew that its young are born live, not hatched from eggs. They painted many images of the bat in their black-on-white ceramic hemispheres, and this one reminds us of paintings by Matisse, eight hundred years before the great French artist was born. Since the bat is a dull gray creature with no feathers, in their images of him they decorated his wings and body in a myriad of designs and symbols, even painting feathers on his wings as shown in this creative depiction. Because of the many similarities between this bowl design and the "Fish Fighting over a Worm" (pages 68–9), it appears to the author that the two are very creative works by the same artist. The realistic delineation overall, with tiny hands on the wings and fierce-looking head with exposed teeth and exaggerated ears, make him a truly exciting subject for dramatic costumes in today's Halloween celebrations. The backgrounds are identical, and the clean, precise style leaps out at the observer.

Despite their apparent intricate understanding of the habits of the bat, the Mimbreños have left us little or no information concerning the position held by this mammal in their pantheon. In Mimbres mythology, bats may have been respected as creatures from the underworld that come out of caves to fly in the night sky. They were illustrated with both flowers and stars on their wings and often with rabbits, animals associated with the moon in some pre-Columbian cultures. Hence, their paintings often depicted bats with large ears or rabbit ears. Bats may also have been associated with resurrection, renewal, or change and, as such, appear on burial bowls for inclusion with the dead.

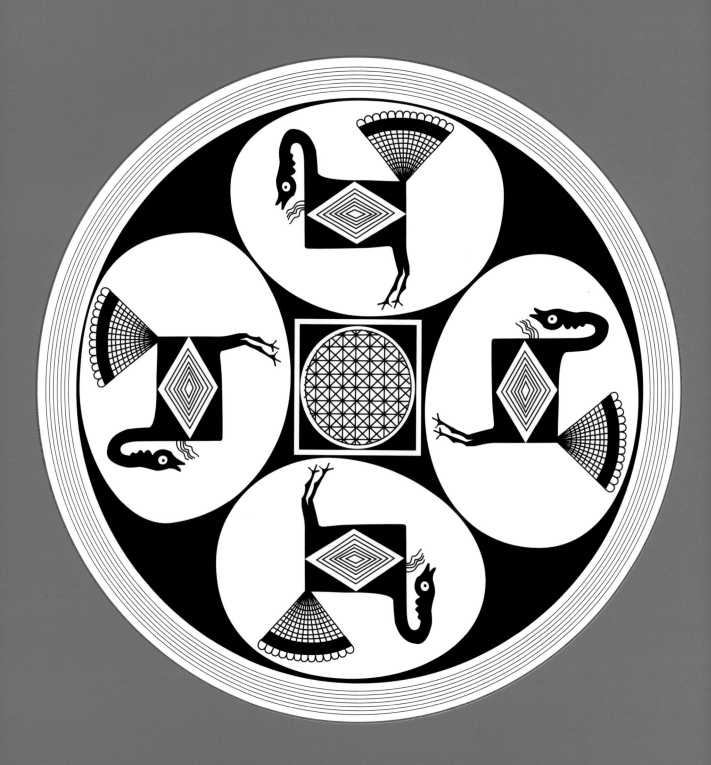

Turkeys were one of the most important elements in the Mimbreño environment, as were other large birds such as Canada geese and ducks. However, turkeys were probably more plentiful year-round than the migrating birds, which were available only seasonally. Mimbreños depicted turkeys on many of their bowls, even trying to illustrate some of the birds' common gobbling and wing-flapping animations. This remarkably refined design is unusually well drawn with exceptional precision and skill. They often divided their designs into four parts, perhaps reflecting their cosmology as we imagine it. Maybe they were indicating that turkeys, hatched from eggs, were found in all four directions on earth and in the sky! The Mimbres artists, for unknown reasons, often illustrated turkeys and animals such as panthers and antelopes with rectangular-shaped bodies. However, they were very capable of more accurately depicting the turkey and panther (see "Turkey," pages 50–1 and "Jaguar or Panther," pages 126-7).

Because Mimbres hunters were able to capture turkeys without killing them (see "Turkey Hunters," pages 148–9), it can be assumed that they might have domesticated them, possibly clipping their wings and raising them in pens for food and for their colorful feathers, which they may have used for headdresses, blankets, and other personal items. It is known from other designs on their pottery that Mimbreños had seen colorful tropical parrots such as macaws from Mesoamerica (see "Parrots," pages 52–3). They may have kept these birds in cages and bred and trained them, using the brilliantly colored feathers for personal and ritual adornment (see "Woman Parrot Trainer," pages 150–1).

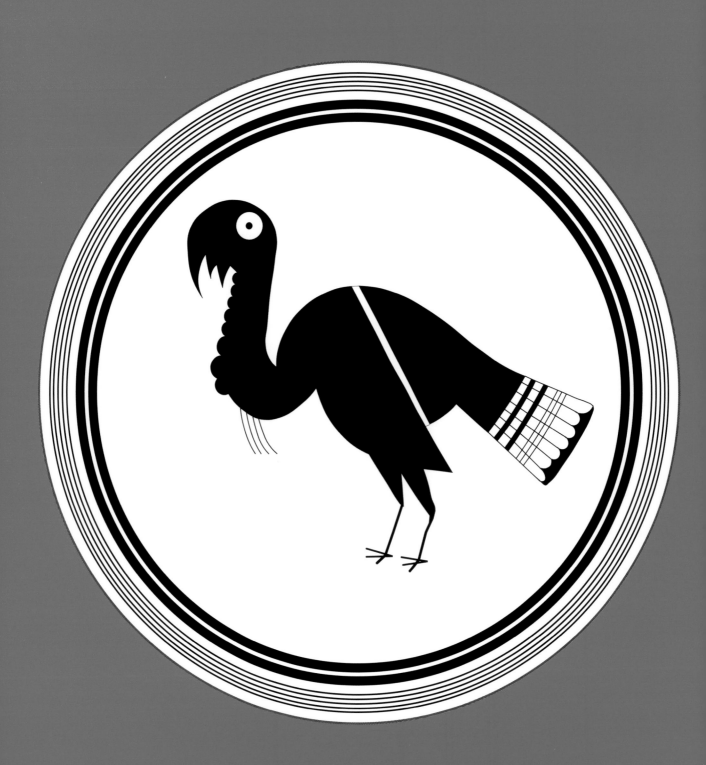

Mimbreño potters illustrated turkeys and other birds and animals in their own styles. The artist who painted the "Turkeys in Eggs" design (pages 48–9) and the artist of this "Turkey" were equally skilled in draftsmanship and both paid great attention to details and realism. But the artist of "Turkeys in Eggs," for some mysterious reason, portrayed turkeys and other creatures as having rectangular bodies, while the "Turkey" artist was able to see turkeys as they really are and paint them that way. Is it possible that the artist who painted "Turkeys in Eggs" painted the "Jaguar or Panther" (pages 126–7) as well, because of the rectangular body delineations and the body applications of symbols on both? The "Jaguar or Panther" is painted with the same realism as the "Turkey." When Mimbreño men hunted turkeys and other creatures they may have disguised themselves as the creature they were hunting. Turkey hunters may have worn hand-made turkey masks on their heads (pages 148–9), and deer hunters actual deer antlers from previous hunts (pages 160–1). Turkeys may have been attracted with corn or cornmeal, making them easy to catch.

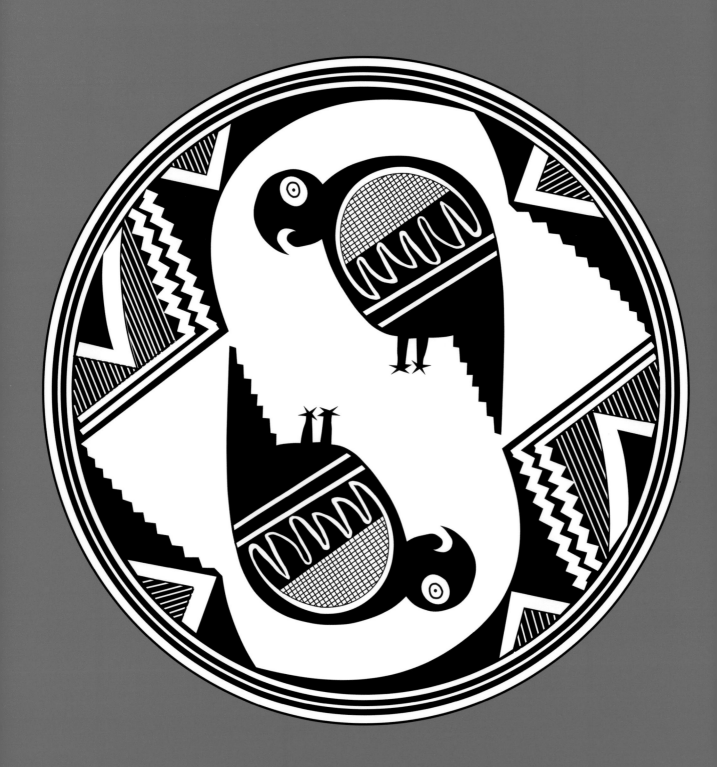

t may be that trade occurred between the Mimbreños and Meso-american merchants, particularly the Toltecs from Tula, north of the Valley of Mexico and the Chichimecs, hunter-gatherers in northern Mexico. The Toltecs, an aggressive merchant and warrior culture, mined obsidian in Central Mexico and used this dark natural glass to craft fine knives and tools. They also fashioned jewelry from copper, silver, gold, obsidian, jade, shell, and turquoise. They raised tropical parrots from the lower Maya area because colorful feathers were desired for personal decoration. Some of these goods were traded throughout Mexico and the American Southwest, perhaps by the traveling merchants referred to as pochteca. In return, the Mimbreños could offer trade goods such as pottery, corn, beans, and possibly turquoise, while the Anasazi to the north may have traded large quantities of turquoise from mines in the Cerrillos Hills south of today's Santa Fe, New Mexico. (See "Turkeys in Eggs," pages 48–9; "Turkey," pages 50–1; "Woman Parrot Trainer," pages 150–1, and "Turkey Hunters," pages 148–9).

Since there is ample evidence in bowl designs of Mimbreños training parrots, it is possible that they may have raised brilliantly colored parrots along with turkeys—tropical birds for their feathers and turkeys for both feathers and as food.

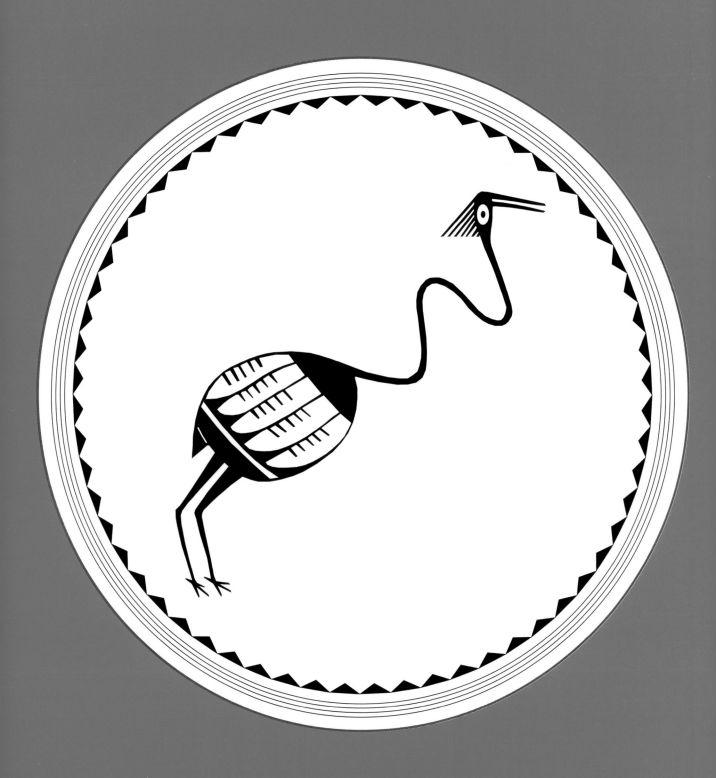

The Mimbres potters took apparent delight in exaggerating the length of the necks of herons and cranes on their pottery. Their many paintings indicate first-hand knowledge of these giant birds' habits and activities. It is not known today whether they were hunted for food but certainly their feathers were highly desired, as were those of turkeys, parrots, eagles, hawks, geese, and ducks. In both historic Puebloan and ancient Mesoamerican cosmology, the heron and crane are considered protectors of warriors and ancestors as well as followers of the sun in their migratory flights north and south. These great birds were associated with water, solstice rituals, and the realm of the dead. Today, the great blue heron is high on the endangered species list but is recovering and slowly increasing in numbers in spite of environmental contamination and the continuing raids on their nest eggs by their natural enemy, the American eagle.

GREAT BLUE
HERON

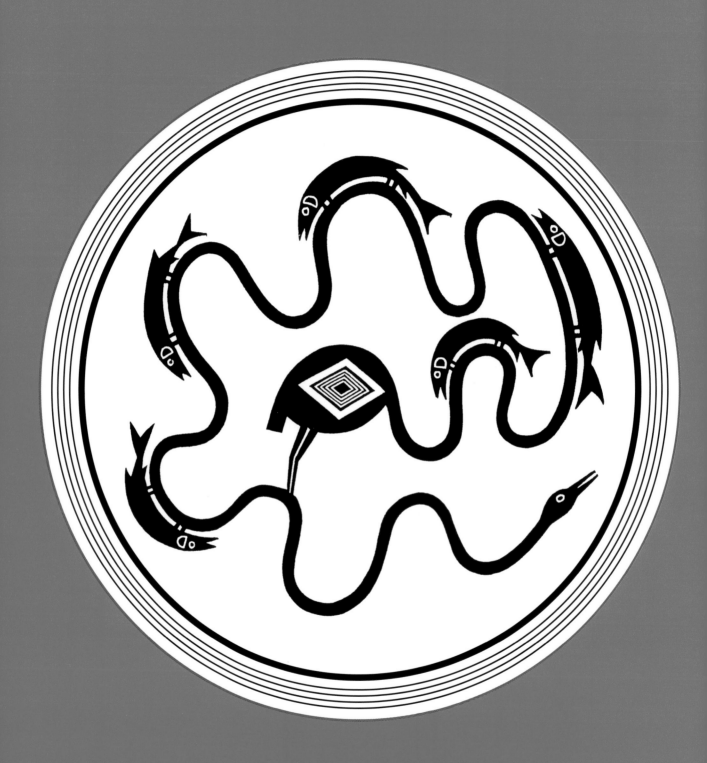

T he most exaggerated stretch of the great blue heron's long neck by the very active sense of humor of the Mimbres pottery painters shows the heron standing in shallow water giving vent to his voracious appetite for fish. Their method of illustrating this is most creative—with fishes so large that the heron could not possibly swallow them, riding down the outside of the bird's neck, which doubles back around, under the water and out again. The heron eats his fill, and more. We don't see the heron's feet because they are under water. The heron bears the symbol of the concentric diamond shapes, which may have a symbolic purpose but have totally mystified today's researchers. Perhaps the symbol's various applications are no more than decorative, space-filling design elements, or perhaps they have some overriding meaning.

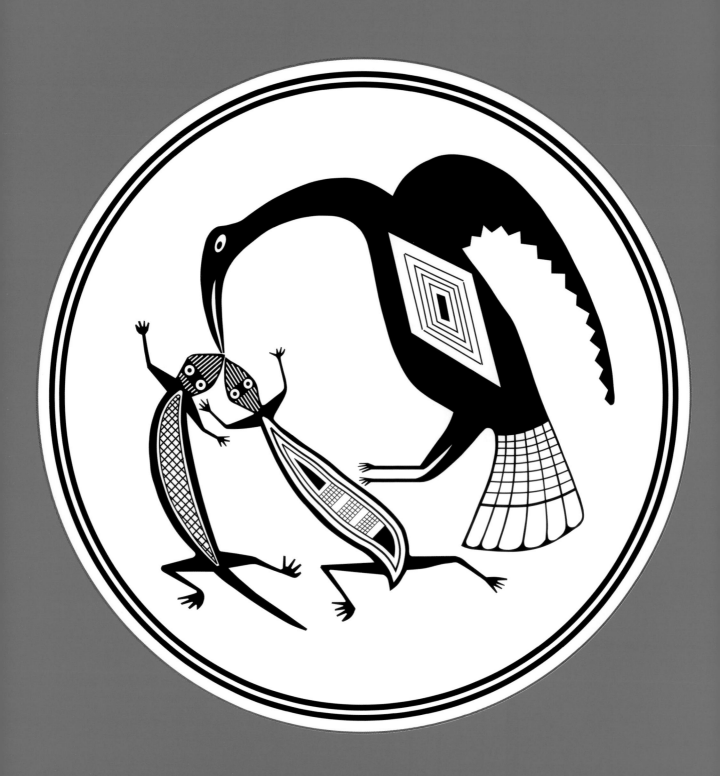

Although anthropological speculation says that this scene possibly illustrates a fable or myth in which a bird and two lizards are talking to each other, a less speculative analysis indicates that the three are struggling over a food morsel, possibly from the stalk of a plant on which they are all pulling in different directions. The artist must have witnessed this scene because the stresses of pulling in the body actions of the bird and lizards are so masterfully drafted. The bird rests on its feet and legs for balance while flapping its wings to help it pull the food upwards and away from the mouths of the lizards—a remarkably successful effort at realistic action animation! If there was a fable based on this scene, it is unlikely that it involved the creatures talking to each other, since none of them has its mouth open. The bird could be an immature ibis, because of its size, characteristic long, downward-curved beak, and presence in the Mimbres habitat today. The Mimbres artists, for some reason, were often inclined to add a turkey tail to birds that, in reality, have none. So it is possible that this is not a turkey at all. Again, there is the concentric diamond design, which happens to occur exactly in the place on the body of the bird where the wing would be contracted, were it not raised above the bird in flapping position.

BIRD AND LIZARDS
STRUGGLE OVER
FOOD MORSEL

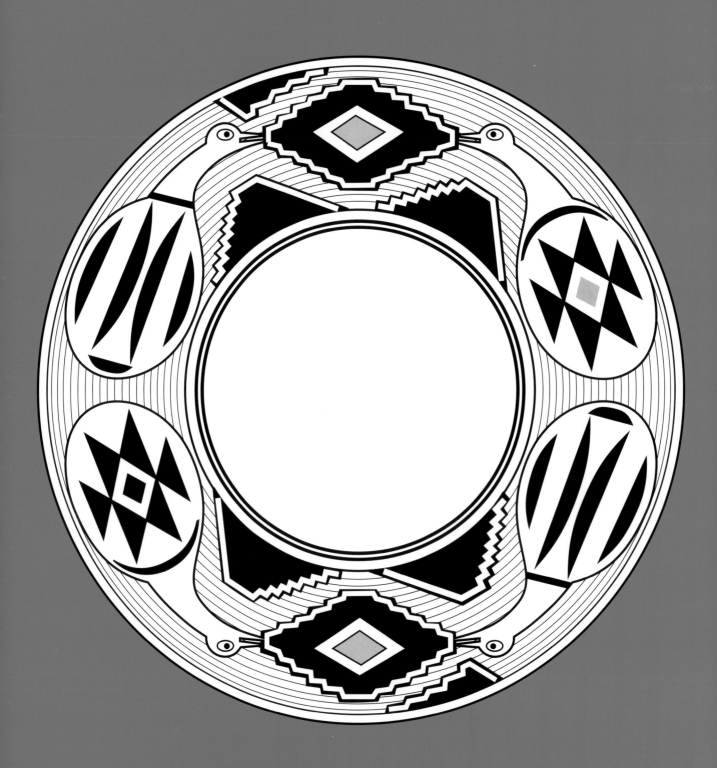

The two diamond-shaped stepped double pyramids, each held in display by two cranes in the design of this unique Mimbres black-on-white bowl, may have been shrine symbols to the Mimbreños in the eleventh century. A shrine would be considered the home of the supernatural being associated with it. It is possible that the gods or spirits appeared in the form of creatures such as serpents, butterflies, mountain lions, and cranes, or as geometric shapes such as crosses, star forms, sun symbols, diamonds, squares, triangles, and spirals.

A shrine is a sacred or holy place where the people place prayer sticks, prayer feathers, or other objects of prayer. It could be an enclosure for ceremonies and dances to be performed in reverence to a particular deity. It could also be something as simple as a spot on the ground, outlined by stones placed in a ring, or be drawn with cornmeal on the floor of the enclosure or on the open plaza where a priest wished to represent a shrine. This bowl was probably designed especially for ceremonies at the shrine of the crane spirit, who may have been venerated as a protector of brave warriors and the ancestors.

One of the major deities of ancient Mesoamerica was Quetzalcoatl, who took the form of a serpent, sometimes resembling a diamondback rattlesnake, adorned with a collar of blue-green feathers from the quetzal bird. Is it possible that the diamond-shaped symbol in this bowl design was derived from the pattern on the back of a diamondback rattlesnake? That might be evidence of a shared visual vocabulary with Mesoamerica. This design has also given us special insight into the important symbolism employed by the Mimbreños. In analyzing the symbolism shown on the bodies of the cranes, it became apparent, with additional research, that the "butterfly" design on the bodies of two of the cranes might be indications of female gender. This, in turn, suggested that the strange symbols on the other two birds might represent the male cranes. This gender theory represents yet another mystery.

SHRINE OF THE
CRANE SPIRIT

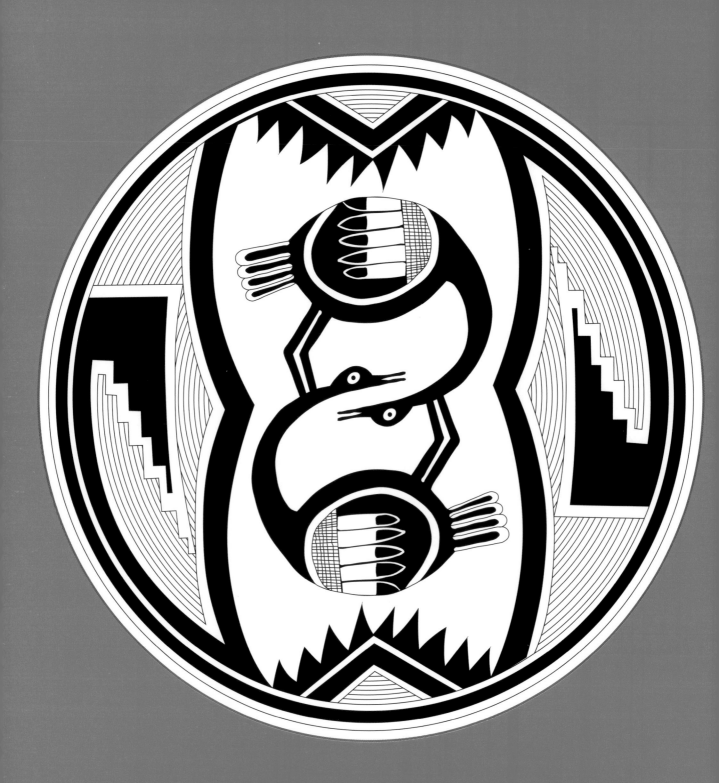

S andhill cranes were and still are one of the most plentiful large birds wintering in the Mimbres milieu. As such, they possibly became an important food source in winter. This highly decorative bowl painting makes an interesting design by intertwining two cranes in opposing positions. In Hopi cosmology, cranes are highly respected as protectors of ancestors. The surrounding decoration employs abstract "cloud-ladders" and jagged saw-tooth triangles to complete a unique frame around the cranes. This design is one of an existing series of six having similar design characteristics, though different subjects, three of which are shown below, suggesting that they might all have been created by the same artist. These are "Scorpion," "Boys riding Bear Cubs," and "Elk on Pedestals." Others are "Parrots" (pages 52–3) and "Pair of Scorpions" (pages 98–9).

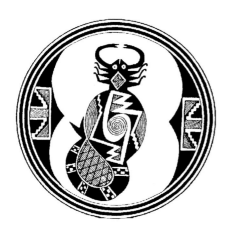
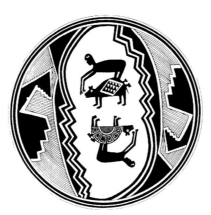
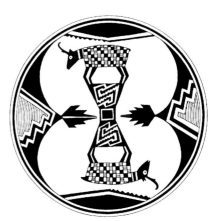

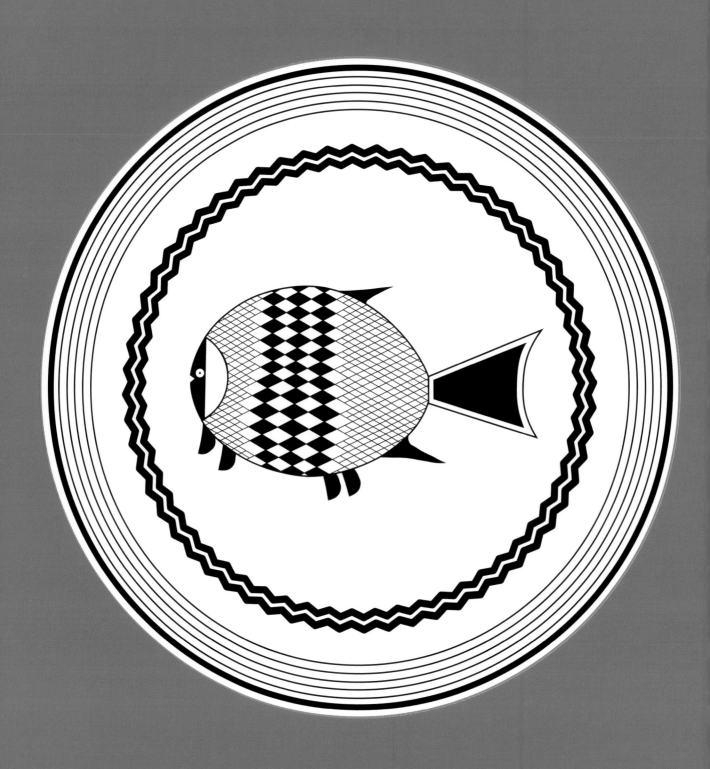

T he particular fish in this Mimbres bowl design looks like a decorated
Easter egg with fins and is only one of a myriad of fish designs illus-
trated by the Mimbres women. The wavy circular border on the bowl was often
repeated as a symbol of water in bowl designs with fish images. Some people
have said that the Mimbres people did not eat fish because no fish bones have
been found in the various excavations, but in some climates fish bones are
biodegradable and it is conceivable that they might have disappeared long before
Mimbres sites were excavated in the twentieth century. Why would a Mimbres
artist have illustrated a proud fisherman standing with a large catch on a
stringer on a beautifully painted bowl if they didn't like to eat fish (pages
140–1)?

SUNFISH

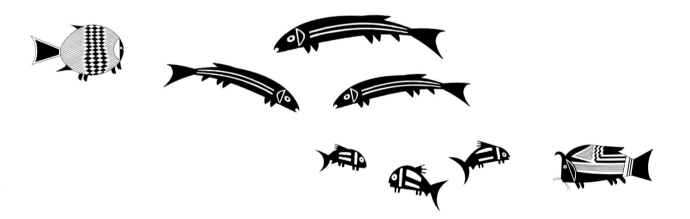

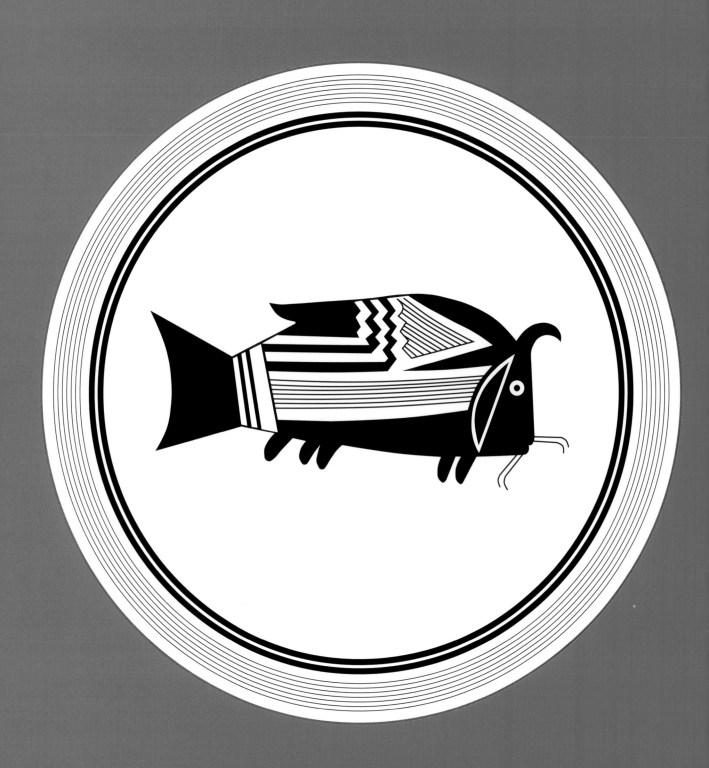

In the opinion of many of today's connoisseurs, Mimbres pottery is superior in design to all other Native American pottery of its time. The figurative designs of the Classic period, so completely unlike the artwork of other native cultures, are the basis for this statement. The Mimbreños exhibited a remarkable understanding of the animal life around them and were able to illustrate it with sophisticated style, animation, and humor. Perhaps this is because many of the animals, fish, and birds illustrated by them were a part of their environment and daily diet. The great number and variety of fish they painted on their bowls suggest that fish was one of their primary foods. It is surprising that so many species of fish lived in their small mountain streams a thousand years ago. Have many of them become extinct? This catfish design is typical of their Classic realistic style with a geometric step design symbolizing water painted on its body, indicating its normal habitat.

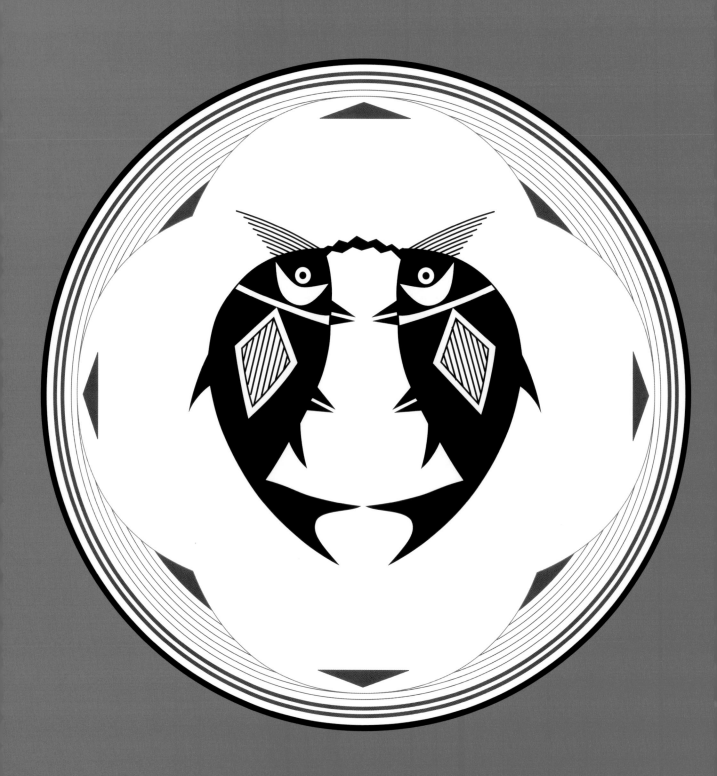

Because of the many similar characteristics between this and the "Bat" bowl design (pages 46-7), it is possible that the two were works by the same very talented Mimbreño potter. The fish and the bat appear against identical backgrounds, and the crisp, precise design character leaps out at the observer. The creatures are realistic and highly stylized. While the bat design is painted in black-on-white, the fish, both fighting for the same worm, were fired with a little too much oxygen, causing the black paint to oxidize to a deep black-brown, actually giving the bowl a very pleasant, antique character. The artist was quite accurate in portraying the two struggling fish, and especially the twists in the worm caused by the rotating of the fish in the water as each struggles to pull the worm away from the other. It shows how closely the artist has observed the subjects directly from life.

FISH
FIGHTING
OVER A WORM

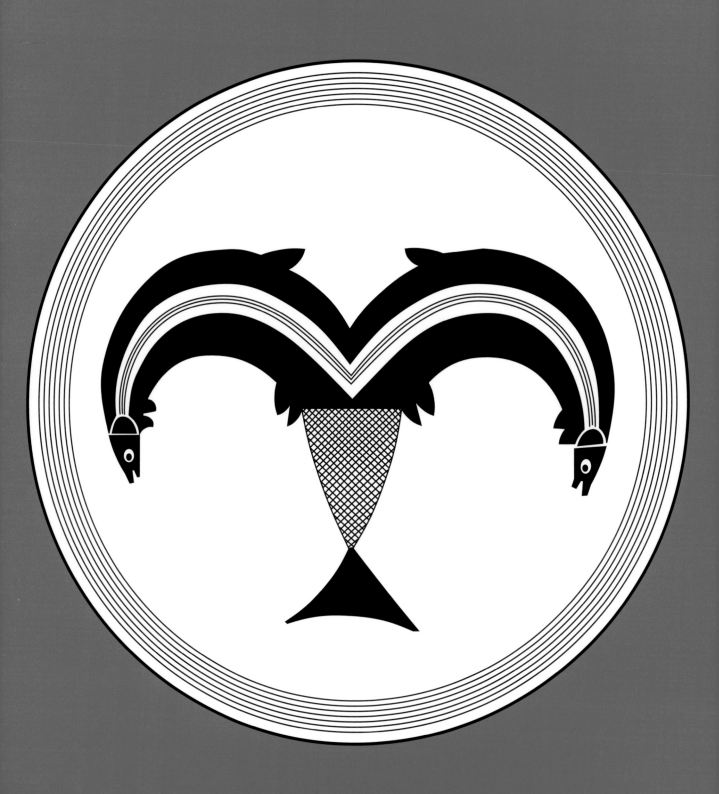

From their close relationship with the creatures in their immediate environment, the Mimbres artists were able to observe and illustrate some rare anomalies, such as the twinned rainbow trout in this pottery painting. Actually, this is one of two recovered pottery paintings illustrating twinned fish, the one being joined at the tail and the other with a single head on two bodies. While they illustrated many varieties of fish on their pottery, since fish may have been one of their staple foods, there is some question whether this bowl was used as a mortuary icon to honor the person at his death who caught this rarest of fish-life anomalies.

TWINNED
TROUT

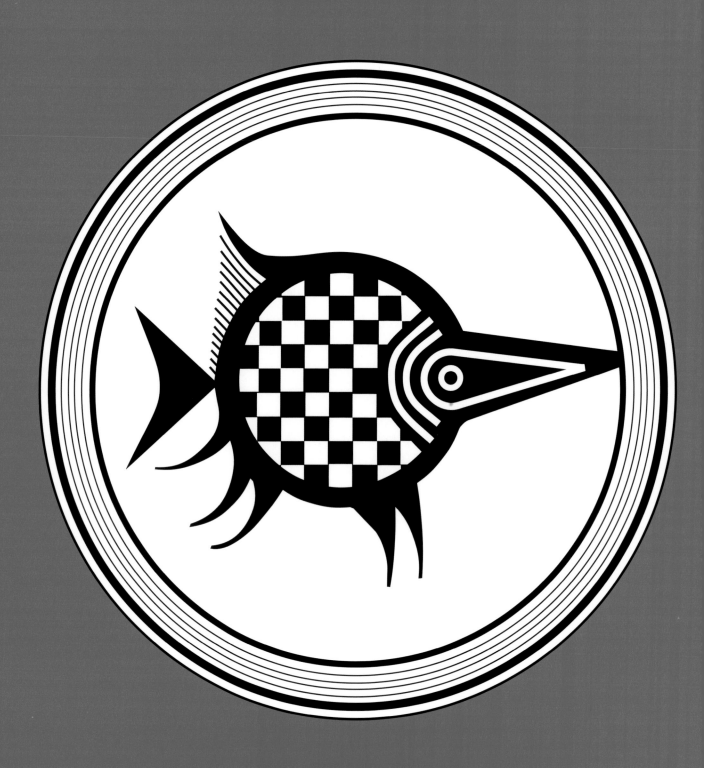

I t is so difficult to believe that a fish of this style would have populated the waters of the Mimbres River early in the second millennium that it has to be one of their many "potter's fantasies" found in the area. Apparently, one of the rare characteristics of the Mimbreño potters, in contrast with others of their time, was their easily expressed sense of humor, fantasy, and satire. Many examples have been found of paintings combining parts of two and sometimes three different creatures as one. There are paintings of comical situations, such as butterflies attacking a large olla of honey carried on a neighbor's head (pages 90–1) and a painting poking fun at hunters losing track of a young deer that has doubled around and is headed in the opposite direction (pages 160–1). There is the comical chorus line of dancing water skaters (pages 108–9) and the paintings of cranes and herons with greatly exaggerated long necks gorging themselves on fish (pages 56–7). These and other characteristics of the Mimbres women potters are what have made their works by far the most celebrated ceramic arts of their time, a thousand years ago in North America.

FISH
FANTASY

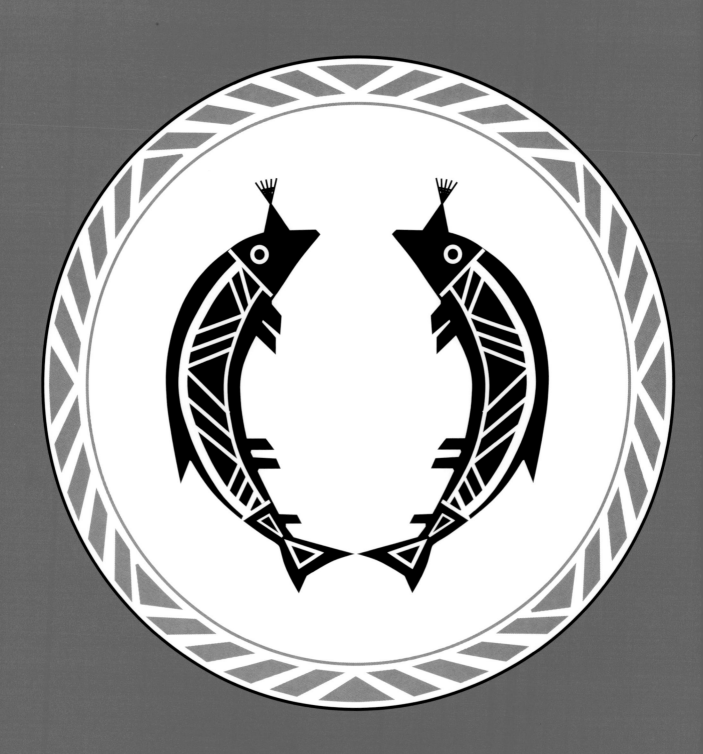

This beautiful hemispheric design of the Classic period depicts two apparent dolphins in their characteristic vertical water dance, facing each other, flapping their tails in the water to keep them aloft above the surface of the water. Native to waters three hundred miles from the Mimbres region, dolphins perhaps were illustrated from stories told to them or by visitors to the coast. It appears now that possibly more trade occurred between these and other areas during the Classic Mimbres period than was formerly realized. Because the design characteristics of the dolphins and the border on this bowl appear to be unique among Mimbres designs and seem to have stylistic similarities to late Toltec art, we consider that it may not actually be a Mimbres design but one that originated in Mesoamerica (see page 142). Since this bowl was found at a Mimbres site, it is likely that the actual origin of it and the "Man on a Beached Whale" bowl might well remain one of their everlasting mysteries.

DANCING
DOLPHINS

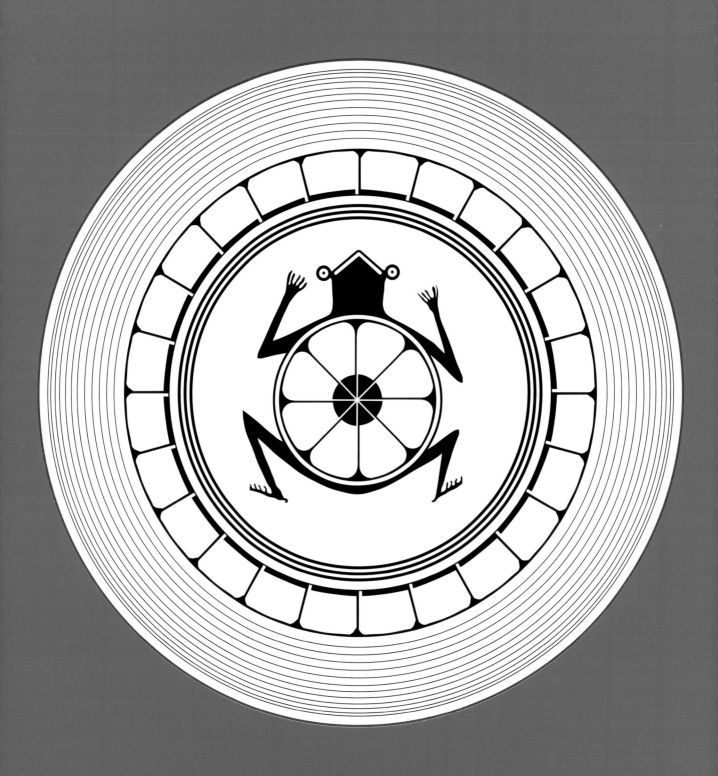

So many bowls and shards with frog designs on them have been found in the various Mimbres ruins that one might assume that frog legs were part of the Mimbreño diet. This cannot be confirmed because under some conditions frog and fish bones biodegrade in much less than a thousand years. The Mimbres women must have enjoyed decorating frog bellies or backs with flowers and seem to relate them with water lilies. This design surrounds the frog with a ring of petals or short feathers creating the impression that the painter might have loved the little creatures like pets. It is not known whether frogs figured in any way in Mimbres religion or cosmology, but it seems obvious that the Mimbreños had a remarkable understanding of the many water creatures in their environment.

FROG

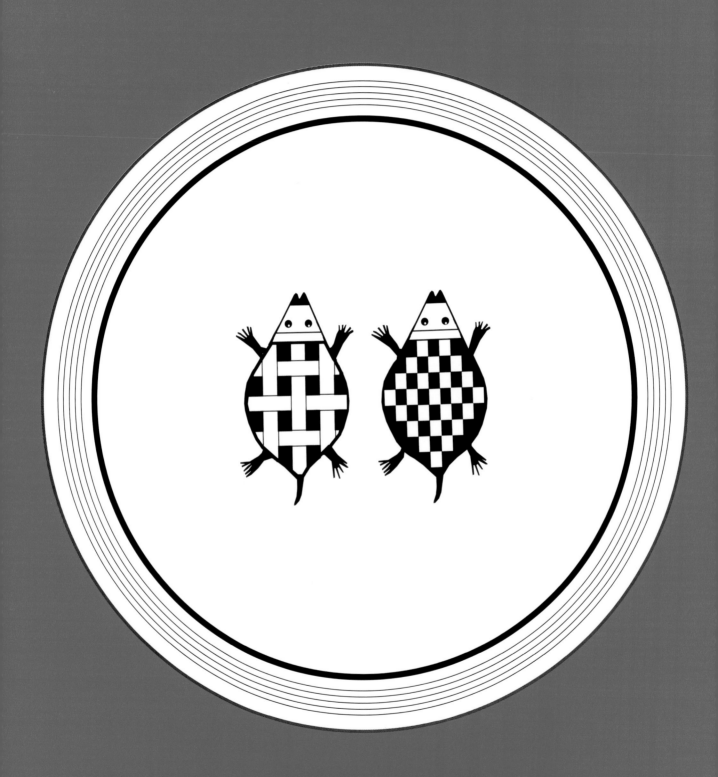

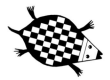 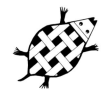

T he woven design on the shell, or carapace, of one the little turtles suggests to us that the Mimbreños were multitalented—they were weavers of baskets and garments, as well as potters! Unfortunately, their woven arts did not survive the nine hundred years before the ruins of their culture were discovered early in the twentieth century, though images of some of them were illustrated on their pottery. No, you can't deduce from the checkerboard turtle that the Mimbreños played checkers or chess, but they were very skilled at creating geometric patterns and designs. On their pottery they decorated turtle shells with butterflies and honeycomb patterns, concentric squares and diamonds, stepped pyramids, crosses and key borders just like the Greeks painted on their amphoras in their Classic period in the fourth century B.C. Whether the Mimbreños ever made turtle soup is still a mystery.

BABY TURTLES

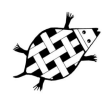 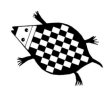 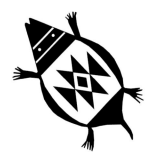

Images of the horned water serpent, an ancient, supernatural deity, can be found today, portrayed on the ritual paraphernalia of contemporary southwestern Pueblo tribes such as the Hopi and Zuni. It appears in several ceremonies of the winter solstice among contemporary Hopi people. The serpent has been found on archaeological ceramics from Casas Grandes in the state of Chihuahua, Mexico, and possibly has its roots in the complex religions of ancient Mesoamerica. It is visually similar to the many serpent deities of the ancient Teotihuacan, Maya, and Toltec cultures.

This original half-bowl was found along with many others by E. D. Osborn on his ranch south of Deming, New Mexico, as early as 1913. In picturing the complete bowl design, we studied other bowl designs that displayed the so-called butterfly design on the turtle carapace. J. Walter Fewkes does not call it a butterfly, as he did with the "Cross and Butterflies" design (pages 86–7), but simply calls it a geometric design similar to that found on birds and animals. Therefore, we decided to adopt the possible symbolism used by the Mimbreños in the "Shrine of the Crane Spirit" design (pages 60–1). Probably this "Horned Water Serpent" bowl, as well as "Butterflies or Women" and "Cross and Butterflies" were used in ceremonies and were designed for that purpose. Obviously, all four designs, including the butterfly itself, leave many unanswered questions.

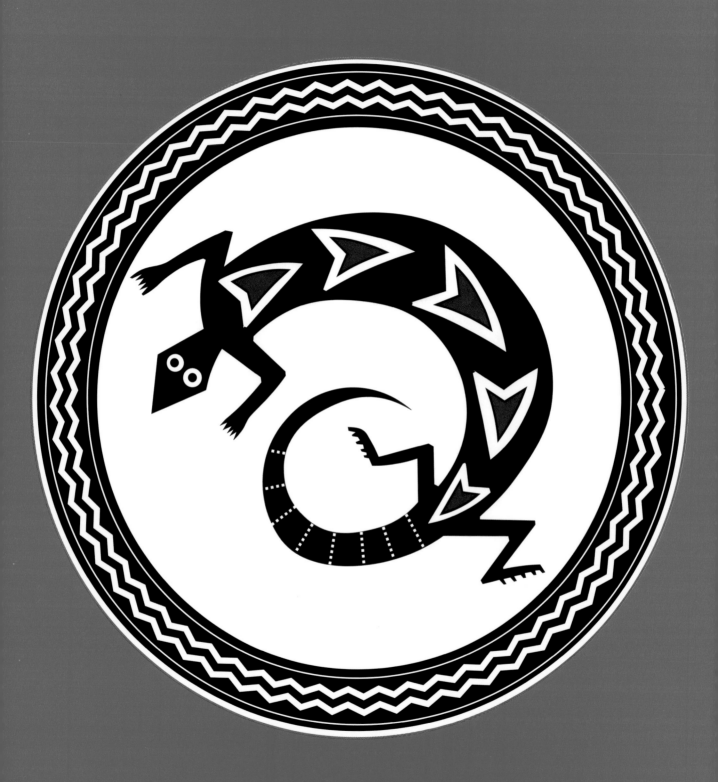

The lizard design in coiled posture is one of the most widely published and copied of all Mimbres designs and happens to be one of their rare polychrome designs, painted in black with earth-red arrowheads on its back. It is probably the most beautifully delineated of all the recovered lizard images. With its water-symbolic black-on-white border, it is especially attractive. Several species of lizards, no doubt, were common to the Mimbres environment a thousand years ago, including the famous Gila monster, but it seems to be quite impossible to recognize the Gila monster in any one of their many unearthed lizard paintings. An example of another Mimbres lizard from a different style bowl and in an extended posture, painted in black, only, on white, is depicted at left. Among some contemporary Pueblos, snakes and lizards are associated with the warrior and water in the underworld and function as protectors of their ancestors.

POLYCHROME

LIZARD

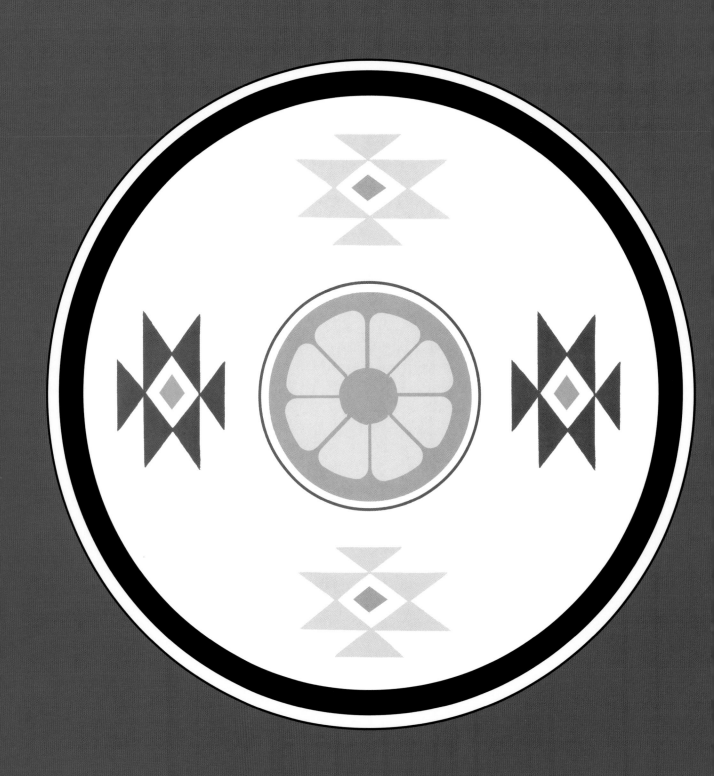

n Mexico, today, many people believe that butterflies are the return-
ing souls of the dead. If this was the belief of the Mimbreños a mil-
lennium ago, this bowl must have been a very appropriate funerary icon for
a recently deceased person. The original of this beautiful Mimbres bowl, in
black-on-white and actually little more than half a bowl, was found in the
Swarts Ruin by archaeologists from the Peabody Museum at Harvard
University in the late 1920s. We have taken the liberty of converting it to color
to express its beauty in terms of today's technology. The mystery in this bowl
design involves an apparent controversy over whether the assemblies of tri-
angles represent butterflies or women, or both as females. Alexander M.
Stephen lived several years with the Hopi Indians in northern Arizona and stud-
ied the symbolism used in Tusayan polychrome pottery, created circa
A.D.1130–1300. In 1890, he submitted a manuscript to J. Walter Fewkes, who
also spent time with the Hopi and was head of the Bureau of American
Ethnology of the Smithsonian Institution. Stephen identified two drawings as
Hopi symbols of women, reproduced at right. Fewkes read Stephen's
manuscript but never published it. In his 1923 Smithsonian publication on
Mimbres pottery, Fewkes identified the Mimbres design on page 86 as a
cross with butterflies, and a similar design on the sides of two cranes simply
as an assembly of triangles (page 87, top). Is the design with the diamond cen-
ter really a butterfly, or might it be a symbol that differentiates female from
male creatures, such as the two turtles in the "Horned Water Serpent" design
(pages 80–1)?

The Mimbres bowl that was identified by J. Walter Fewkes as a cross with butterfly symbols was found by E. D Osborn on his ranch south of Deming, New Mexico, around World War I (left). The bowl that we call "Shrine of the Crane Spirit" (60–1) was also excavated on Osborn's ranch. Fewkes, in his Smithsonian Institution publications, illustrated at least three bowl designs with what we consider the butterfly design, but only identified the motif of a cross and butterflies as such. Fewkes identified his drawing of our "Shrine of the Crane Spirit" bowl as birds with swollen bodies. His description referred to the butterfly design on the side of the two birds as simply a group of triangles. In discussing his drawing of the "Horned Water Serpent" design (pages 80–1) he referred to the butterfly on the carapace of the one complete turtle as a geometric design similar to that found on animals. As we have learned, slightly different forms of the so-called "butterfly" design may have represented "woman" and possibly the female gender to the early Hopis. Some Mesoamerican cultures such as the Mayas and Toltecs worshipped butterfly gods and goddesses. In the Toltec religion, the butterfly may have represented the human soul's immortality. Toltec warriors wore butterfly-shaped chest protectors in battle. The butterfly seems to have held a position of some prominence in Mimbres culture.

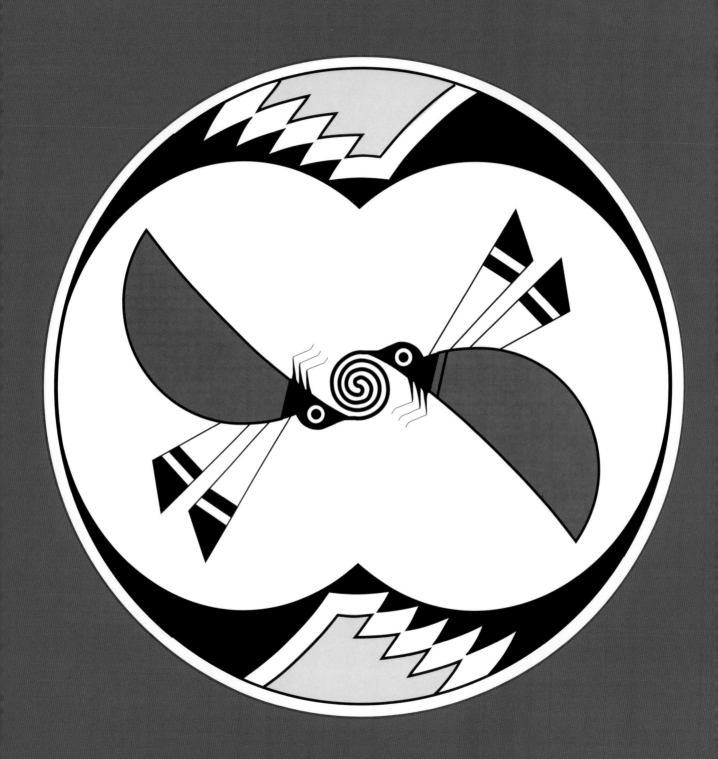

Because this Mimbres design includes two border bands of clouds with jagged lightning, the viewer immediately comprehends that the pair of yucca skippers is in flight. The skippers, though harmless, can startle people as they dart among plants at dusk. It is not difficult, from this painting inside an attractive and colorful bowl, to determine what species of insects is illustrated. The spiral proboscis occurs only on insects of the order Lepidoptera, including butterflies, skippers, and moths, and is an important part of the design concept, though it is doubtful that any two such insects ever flew with proboscises united, as drawn. Possibly recognizing the spiral as a symbol of fertility and breath, the artist could have assumed that this is how skippers mate. Because the Mimbreños' high desert, mountain valley environment includes a great many yuccas, these insects are probably yucca skippers. The yucca skipper lays eggs in the yucca stalks and the larvae hatch and feed on the yucca stalks. Eventually, the larvae become yucca skippers that feed on honey through their proboscises as they dart from flower to flower, usually at dusk.

It's surprising what we can learn from ancient art one thousand years later. The yucca is one of the most important plants of the Southwest. The Mimbreños used parts of the plant for food, clothing, strings, tools, paintbrushes for decorating their pottery, baskets, sandals, back-mounted child carriers, general material carriers made of willow rods woven together with yucca fibers, and they used yucca roots as food and to make soap. In addition to the yucca skipper, a tiny yucca moth about one inch long is essential to the yucca's reproduction. The female moth carries pollen to the stigma, fertilizing the eggs, which form seeds. The larvae feed in the seeds and pupate in the spring.

As a people without modern conveniences, the Mimbreños likely were plagued by a great variety of insects, despite which they seemed to enjoy painting them in rich detail and color on their remarkable polychrome hemispheric pottery (see also "Polychrome Butterflies Seeking Olla Honey" (pages 90–1) and "Polychrome Wingless Moths or Ant Lions" (pages 104–5).

POLYCHROME
PAIR OF
YUCCA SKIPPERS

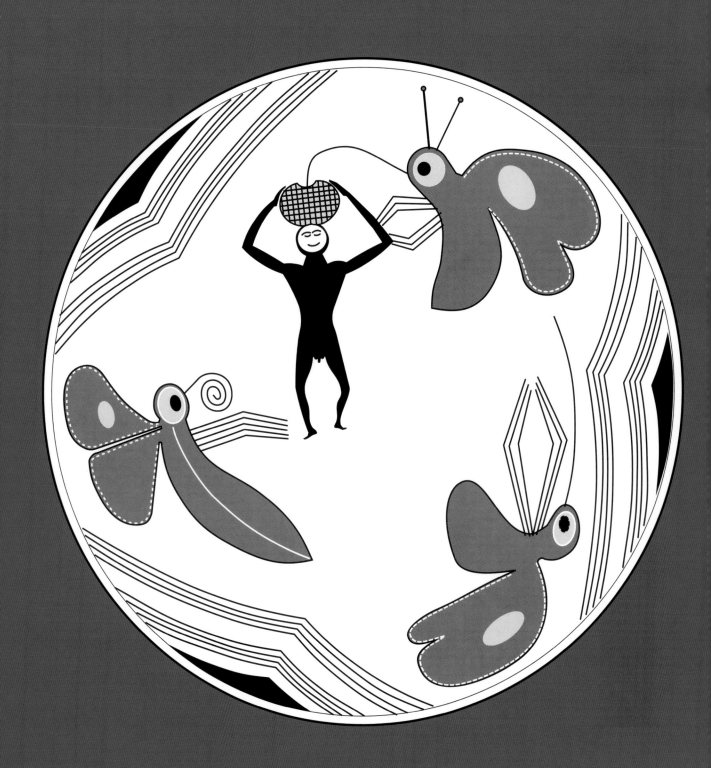

One of the most impressive among all Mimbres painted bowls, this is also one of only a few scenic views existing of interaction between a Mimbreño man and creatures in his environment. And even more notable is the point of view taken of the scene by the artist, and the sketchy, feminine character of the rendering of the scene.

A great number of singular views of creatures close-up are included in this collection, but the paintings that stand out are those that take a broad view of collective action, most often viewed from above. The Mimbres artists, like no others of their time, had a unique curiosity and biological interest in all living creatures in their environment and a talent for seeing life differently, with humor, satire, and sometimes through the eyes of others, as in this distinctive scene. The creative artist here has assembled a picture that tells a story of a special humorous happening in which a male Mimbreño is returning from collecting honey from beehives in the woods and is carrying the honey in an olla, or large jar, on his head. Apparently several insects, possibly buckeye butterflies and skippers or moths identifiable by their spiral-coiled proboscises, detected the honey in the olla and are darting around above the honey jar seeking to get at it. The truly memorable part of this picture is that the artist's viewpoint is above and among the insects as if he were one of them, flying around taking a snapshot of the scene.

POLYCHROME
BUTTERFLIES
SEEK OLLA
HONEY

T he harmless dragonfly is one of the many water insects that the Mimbres seemed to enjoy illustrating in their black-on-white pottery. The Hopi and their ancestors have always venerated the dragonfly. They often asked the dragonfly to confer benefits on their people. Dragonflies are portrayed on altars, pottery, and petroglyphs because the Hopi believe that dragonflies have great supernatural powers and are shamanistic. They are positive symbols of water, fertility, and abundance. The Hopi people actually credit dragonflies with saving their tribe from starvation by using their supernatural powers to grow corn to maturity in four days, at the ancient time when their tribe was migrating in search of their permanent home. Their geometric symbol for the dragonfly (above) is commonly found at Hopi. Dragonfly song is believed to warn men of danger and resembles the Hopi word for water: *tsee, tsee, tsee.*

The Mimbreños exhibited remarkable understanding of insects in their environment, some harmless, some irritating, and others dangerous, being capable of illustrating them with sophisticated style, animation and humor. With the variety of foods that they stored and prepared daily, and the lack of modern sanitation in their way of living, there must have been a great variety of insects, bugs, lizards, and small animals attracted to their pueblos. Apparently, the Mimbreños were able to deal with them with a surprising tolerance and humor as delineated in their beautifully stylized dragonfly bowl (opposite).

DRAGONFLY

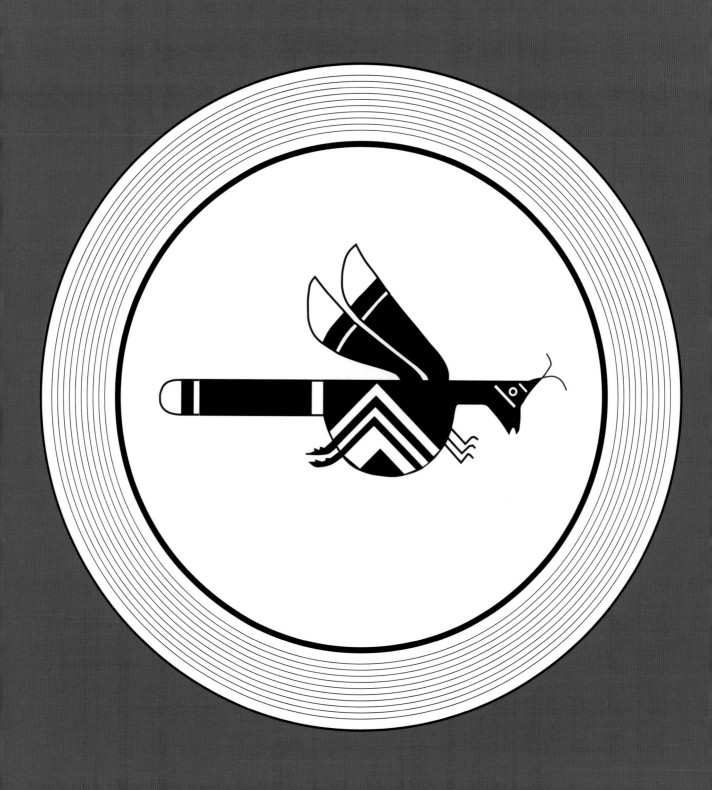

B ecause some Pueblos were known to have been eating roasted grasshoppers during periods of drought in the late nineteenth century, it has been speculated that the Mimbres people may have included grasshoppers in their diet as well, in season. Indeed, the Mimbres illustrated grasshoppers in many ways in their painted pottery, just as they did other known elements of their diet. However, because of biodegradation and the destruction of archaeological sites, it is difficult, a thousand years later, to be certain grasshoppers were adopted as food. It is definitely possible that, in times of summer drought when food of all kinds might have been scarce, they could have been desperate enough to eat any form of life common to their environment, but there is no evidence to support such speculation.

This smartly styled side view of a grasshopper certainly indicates considerable respect by a very talented creative ceramic artist for an insect that could have had a rapacious and destructive effect upon their carefully planted crops and thus their food supply.

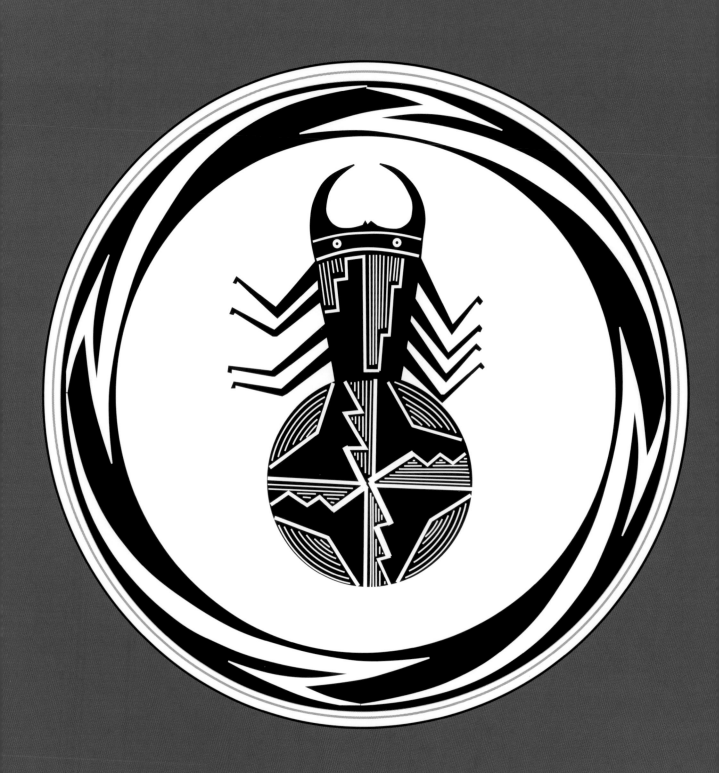

Among the purchases by J. Walter Fewkes from private individuals in the region of southwestern New Mexico where the Mimbres ruins were being ravaged by curious collectors, was this amazing beetle on a shard, without the original border of the hemispheric bowl. In 1914 Fewkes had traveled to Deming, New Mexico, from Washington, D.C., to see first-hand the ceramic pottery and ancient ruins about which E. D. Osborn, a rancher near Deming, had written him. Many of the settlers in the area were finding the pottery and other ancient Indian artifacts on their properties. While there, Fewkes gathered some examples and returned to Washington with a considerable collection, which he subsequently published under the auspices of the Bureau of American Ethnology of the Smithsonian Institution.

In order to illustrate this distinctive beetle design in our collection, we had to solve the design problem of the missing rim. Liberties were taken to show a complete bowl as we imagined it might have been. Could this be a painting of the Toltec god, Pinahuiztl, a beetle who represents the Toltec astronomical system (see "Beetle Ball Game," pages 144–5). A border with lightning characteristics was borrowed from another bowl to complement the lightning in the beetle design itself. The Mimbreños often used such effects on other fierce-looking creature designs.

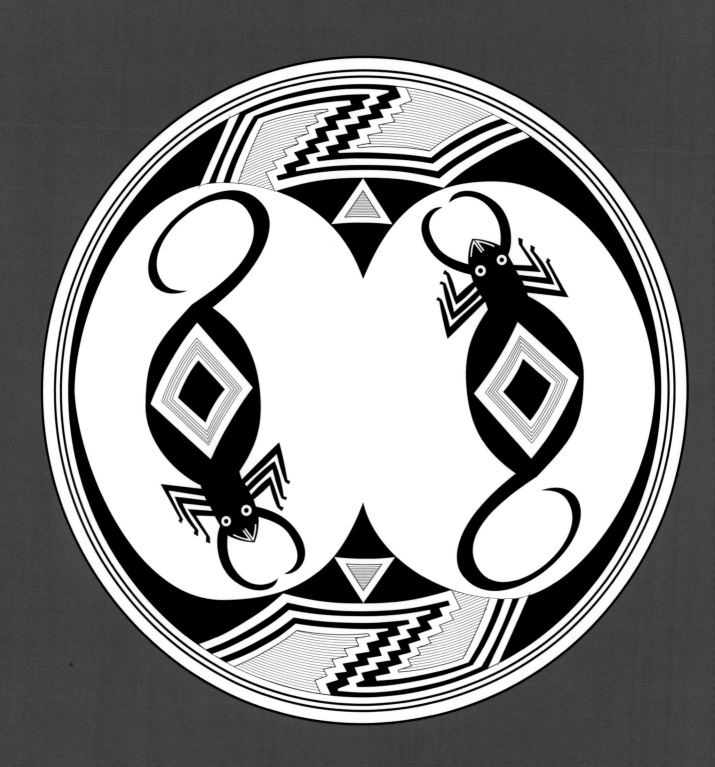

On their painted pottery the Mimbreño artists often labeled fierce, dangerous or poisonous creatures or those having special powers with lightning symbols. In the bowl design, the symbols were either on the creatures' bodies or next to them, such as the border in this "Pair of Scorpions." An identical lightning symbol was used again on the backs of the "Pair of Coatis" in an attractive bowl (pages 124–5), which suggests that both scorpions and coati were considered dangerous creatures. Possibly, both bowls were outstanding works of the same distinguished artist.

Two additional symbols, mentioned before, are the mysterious concentric diamonds on the backs of the scorpions, which occurred previously in this series only on birds and water life. Is it possible that these concentric diamonds were clan symbols, indicating that these bowls were designed especially for use in designated clan ceremonies?

PAIR OF

SCORPIONS

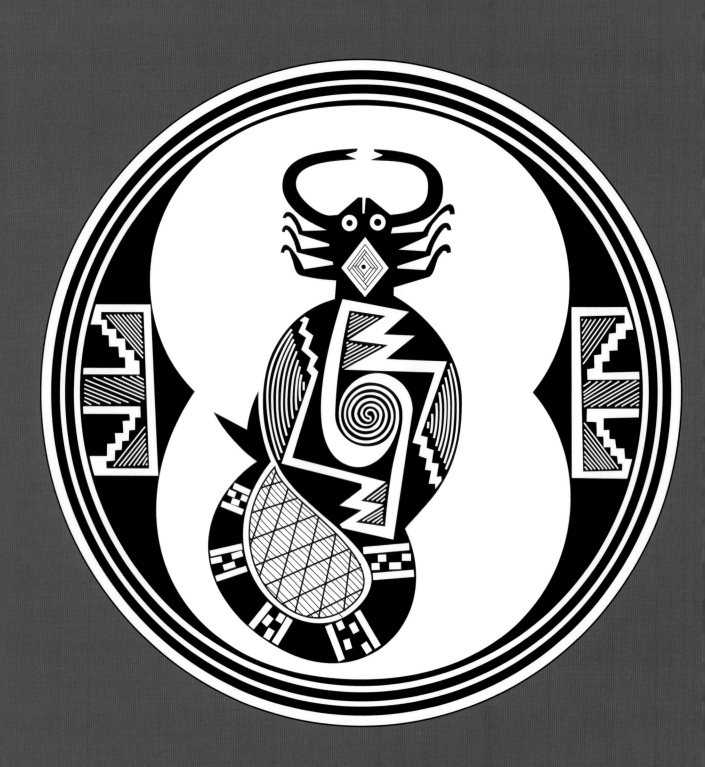

This distinguished delineation of the scorpion is one of an outstanding group of six or more Mimbres bowl paintings that we assume to have been the work of one truly talented artist (see page 63). Each one of these designs is rich with decorative symbolism, challenging the viewer to determine the many meanings projected by the painter. The unique diamond shape applied to the head of the scorpion may be a shrine or clan emblem. Just below on its back is an assembly of lightning and a centering spiral. Lightning, of course, warns of his very poisonous sting, while the spiral, a whirlwind that accompanies lightning before the storm, emphasizes his powers. The checkered bands on his tail represent restraints on his tail, which carries the powerful sting. The black border includes on each side a symbol that has mystified anthropologists and art historians ever since it was first seen by them. It is in the shape of the Greek letter "Tau." This symbol may have its roots in the Mesoamerican pantheon.

SINGLE
SCORPION

T hree outstanding hemispheric bowl designs (pages 102–3) graphically illustrate the Mimbreños' creative imagination and sense of humor. One artist painted a remarkable pinwheel using five "birds' heads" with a centered, five-pointed star. Another bowl shows a single creature that greatly resembles the ones in the wheel, possibly having been created by the same artist (below). The first bowl was found circa 1913 by E. D. Osborn on his ranch, while the second was found in the Galaz Ruin, many miles away in the 1970s by Steven A. LeBlanc and his archaeologists from the University of Minnesota. The authenticity of the "birds" in the pinwheel design may be questioned because each has three pairs of legs instead of the single pair common to all birds. Also, the single creature in the design below has four pairs of legs, indicating that it is an insect. The third bowl design, "Polychrome Wingless Moths or Ant Lions" (pages 104–5), shows two very similar insects that seem to be Lepidoptera because of the enjoined spiral proboscises. However, the heads of the two creatures are almost identical to the five in the wheel, except that the five have no antennae. Fred Kabotie, the Native American authority, says that the two are "sand blowers." Others have suggested that all three may be the larvae of predator ant lions, insects that create conical depressions in sand and lurk at the bottom of the cone to capture wandering ants or other small insects. This spurred a revelation: Is it possible that the bug wheel is an animation of one ant lion larva going through the gyrations of burrowing and blowing sand to create the conical depression in which it will capture and eat ants and various other small insects?

BIRD WHEEL
OR
ANT LION
WHEEL

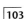

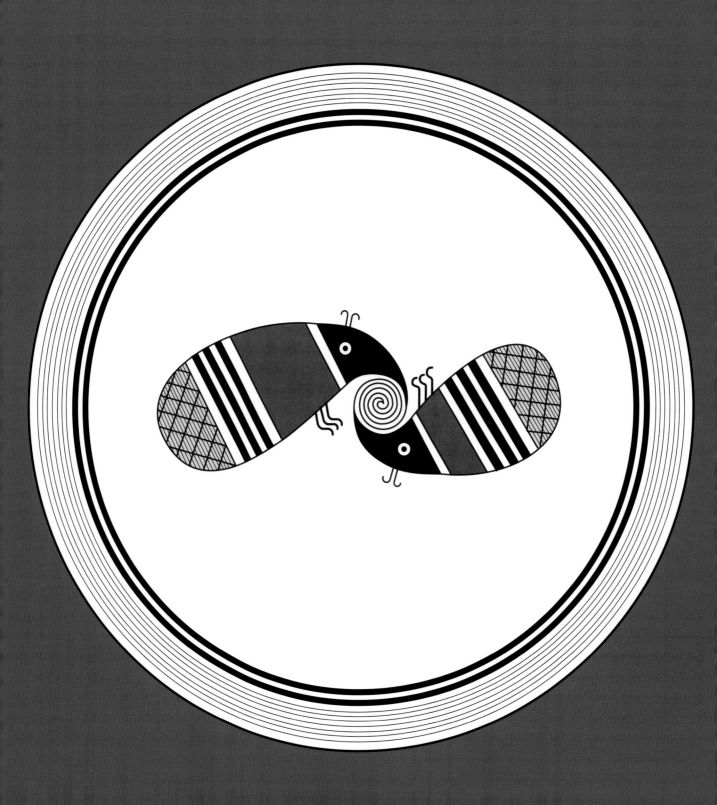

t is apparent that these creatures are moths because of their spiral proboscises. In several species of moths, the female is born without wings and hence is unable to fly. The idea that one moth will feed the other through the spiral proboscis seems to be a figment of the Mimbreño artist's fertile imagination and as an artistic device may have evolved in the creator's mind's eye from the spiritual meaning of the spiral as a symbol of both fertility and breath. However, the heads of the two creatures appear to be ant lion larvae. Here we have another case of combined elements. Other Mimbres pottery designs exist that combine the ant lion larvae with the spiral as a symbol of the conical depression, or perhaps as a representation of the *sipapu*, a symbol of the Pueblos' place of emergence from the underworld. Regardless of its meaning to its creator, this and possibly other insect paintings, "Polychrome Pair of Skippers" (pages 88–9), "Polychrome Butterflies Seeking Olla Honey" (pages 90–1), and "Bird Wheel or Ant Lion Wheel" (pages 102–3) are singularly handsome designs. The similarities between these four designs must not be ignored. The focus on Lepidoptera and ant lions as subject matter, the stylistic relationships, and the delightfully creative sense of humor all point to a singularity of concept and skill as so often found in one talented artist.

POLYCHROME
WINGLESS MOTHS
OR
ANT LIONS

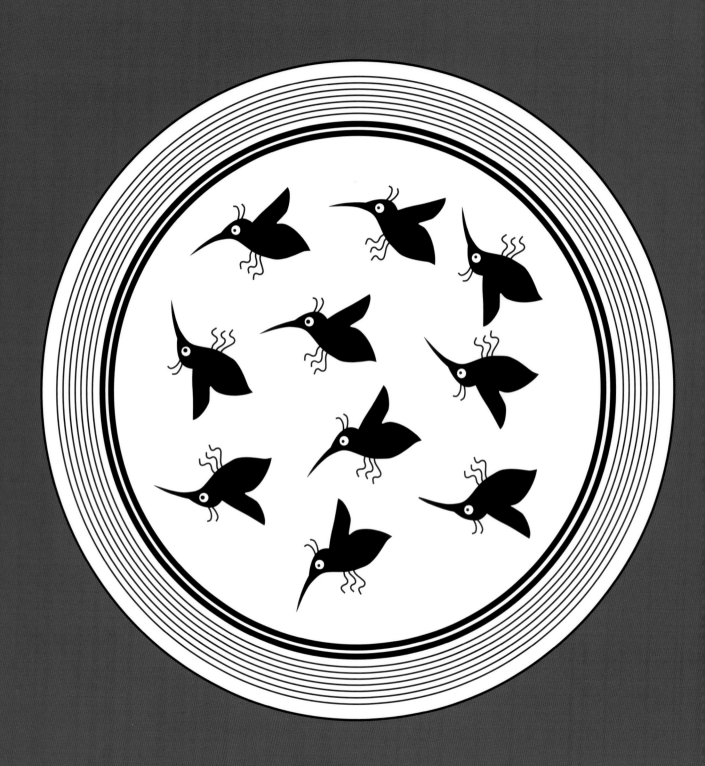

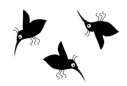

Very few creatures living in the warm Mimbres environment were so small as to escape the artistic eyes of the talented Mimbres potters. Some were like pets, many were food for their families, and some challenged their curiosities, as hummingbirds might. Others were probably irritants, such as mosquitoes, and still others were dangerous threats to their health or well-being, such as bees and scorpions, bears and mountain lions. At first glance, the long beaks of these creatures might suggest that they are hummingbirds, but have you ever seen hummingbirds swarm and fly upside down, as these are doing?

MOSQUITOES
OR
HUMMINGBIRDS

Have you ever wished you could walk on water? Water skaters, of the family Gerridae, are spidery-looking harmless insects a little less than an inch long whose only claim to fame is that they scamper across the surface of the water on ponds, creeks, rivers, and lakes throughout the Southwest as well as other regions of the U.S. Because of their timidity, many Native Americans call them "water deer." Today, the Zuni believe the water skater was given magical powers by the sun god and, according to ancient cosmology, stretched out his four legs toward the solstice points and located their "center place" where the present Zuni Pueblo was established. It is not surprising, then, that the Mimbreños would have depicted it on their pottery with a tail, sunning itself on a star-shaped lily pad in the water (right). But the design on the bowl opposite seems to be attributable only to their rich sense of humor. Several ceramic black-on-white bowls found by people in ruins along the Mimbres River bear painted images of the little creatures, but the most humorous is this whimsical polychrome "chorus-line" of water skaters dancing across the middle of a small food bowl, only six inches in diameter.

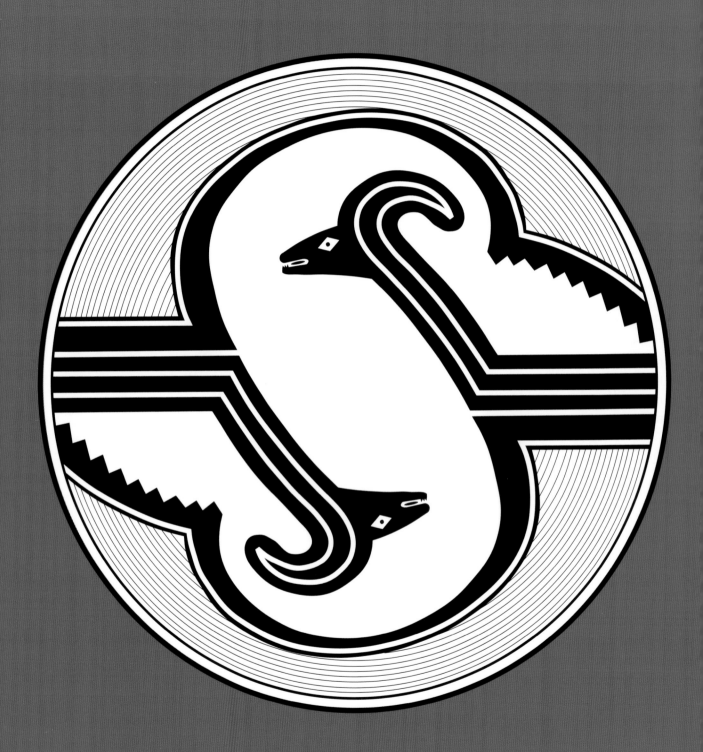

O ne of the few Mimbres black-on-white bowls unearthed in good condition, without a "kill hole," this is also one of the most skill-fully designed and precisely painted pieces among the thousands of ceramics found in the Mimbres milieu. Conceived, designed, and painted with stylistic precision, it stands out as a choice piece among Mimbres collections. It is also one of the early representations of large wild animals in the Classic period of figurative Mimbres ceramic painting. The Mimbreños hunted mountain sheep, deer, elk, and pronghorn antelope, all large wild game common to the mountain valleys and the beautiful mountains known today as the Black Range of the Gila National Forest.

It is not known whether the Mimbreños were able to domesticate sheep for food and hides for winter clothing. The wild game fed and clothed the Mimbreños well for hundreds of years. By A.D. 1150, many of the Mimbreños had migrated away from their large mountain valley settlements, seeking farmlands not affected by drought on which to get greater crop yields.

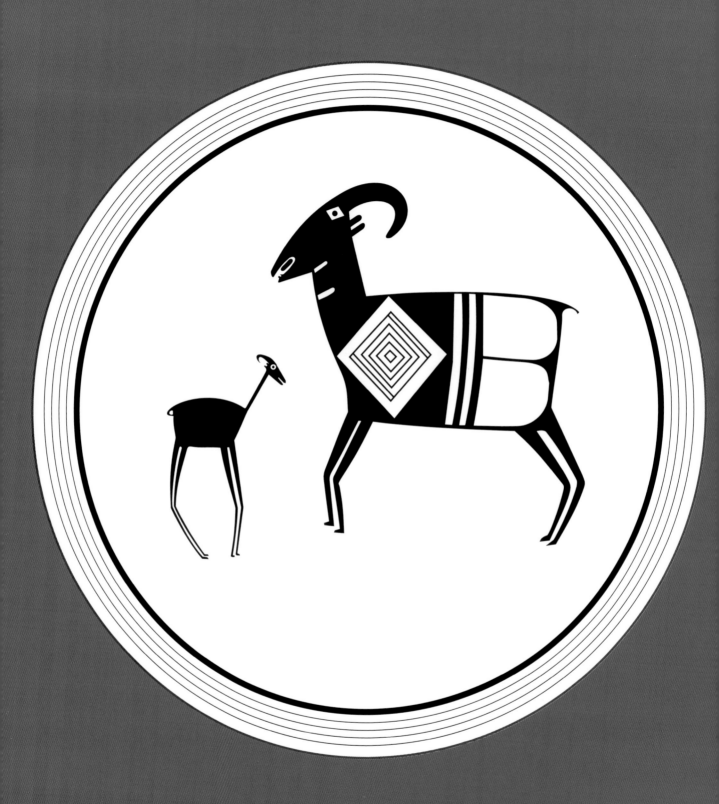

The two distinguished Mimbres black-on-white hemispheric bowls shown below, one bearing the adult goat and the other the spindly shanked, just-born kid, were combined here to be able to show both design treatments in a familial format. The beautifully refined design characteristics of both animals are so well styled and so alike in design character as to suggest that both were created by the same artist. Again, the concentric diamond that may be a shrine symbol appears on the side of the adult goat, indicating the bowl's possible use in shrine ceremonies. It makes a truly pleasing design but one that is difficult to understand or explain today. It is not known whether the Mimbreños were able to domesticate mountain goats to raise them for meat, milk, and hides for clothes.

MOUNTAIN GOAT
AND
KID COMPOSITE
DESIGN

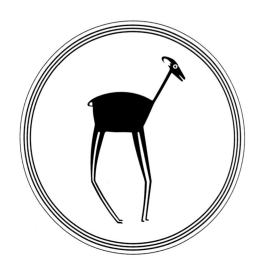

Many of the animals illustrated by the Mimbres on their pottery must have been a part of their food source. However, their relationship with rabbits was unique—rabbits, being plentiful in their environment, were their staple meat diet. Yet, they obviously loved the little creatures, judging from the sensitivity with which they depicted them in their bowl designs (see frontispiece, "Revered Rabbit"). Whether their images on so many bowls simply represented their most common meal or whether the rabbit, to them, carried the spirit of fertility, they displayed his image in countless ways on their pottery. Just as the Hopis considered themselves to be made up of corn, the Mimbreños possibly thought of themselves as part corn and part rabbit. Similar to other pre-Columbian cultures such as the Aztec, the Mimbreños may have believed that rabbits had lunar significance. Rabbits were shown with a crescent moon in many bowl paintings, and the arch in the rabbit's back was associated with the crescent moon. This outstanding stylized Classic rabbit design is from the 1931 archaeological discoveries of Paul H. Nesbitt in the Old Town Ruin on the Mimbres River, a few miles northwest of Deming, New Mexico, where he found many others.

RABBIT

One of the rarest of all the many, varied rabbit designs produced by the Mimbres ceramic artists is this portrayal of the mother rabbit giving birth to at least four babies, in which two of the unborn rabbits are shown in cutaway view inside the body of the mother. The use of the cutaway or "x-ray" view, common to Mimbres ceramic art in the Classic period and to technical illustration in the twentieth century, occurs rarely in the art of other small-scale societies of the world in their time. It also illustrates the intense interest, curiosity and in-depth knowledge that the Mimbreños had of the habits and general biology of the creatures in their environment. This was a natural result of the rabbit being their primary animal source of food, but their interest seems to extend far beyond the creatures in their food chain to even the tiniest of insects such as mosquitoes (pages 106–7) and water skaters (pages 108–9). In this painting, the animated tumbling positions of the babies, both inside and out of the mother, and the surprised expression on the mother's face again indicate the rich sense of humor of the artist. The picture in this bowl was painted with outstanding refinement and draftsmanship demonstrating the exceptional skill of this particular artist.

RABBIT

GIVING BIRTH

One of the interesting things about the Mimbreños who designed and painted pottery is that each one had a unique style. Among the thousands of pieces of pottery discovered by archaeologists and individuals, several have been identified as having been the work of one distinguished artist. The artist who created this design is recognized for her many unique reverse white-on-black designs of rabbits, painted in this clean, "modern," realistic style, causing some anthropologists and art historians to refer to the artist as the "Rabbit Master." The design below (left) includes the figure of a large bird, possibly a crane. The double jagged lines below each rabbit (below, right) have been described by anthropologists as a fertility symbol.

WORKS OF THE
RABBIT MASTER

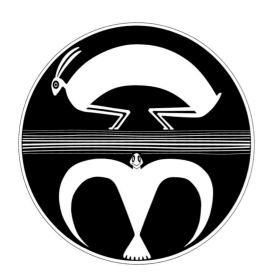
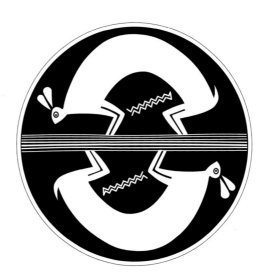

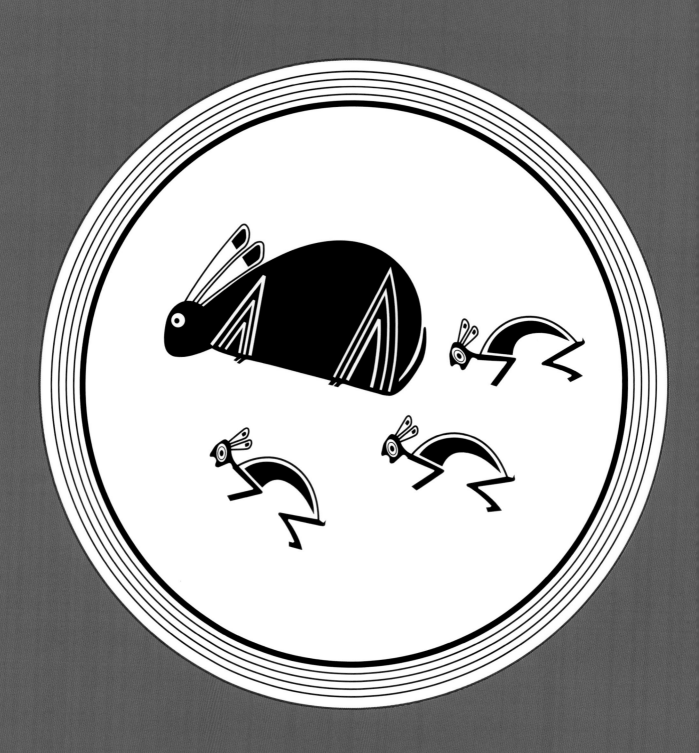

An adaptation made entirely from design elements created by Mimbres artists in other bowl paintings, this family scene is made of simplified, almost geometric rabbit designs that seem to belong together. One baby rabbit was found on a shard that is about one-third of a bowl. By reproducing it twice while changing their body angle we had a scampering trio of the most creatively animated youngsters imaginable, while the large rabbit, a lonely animal from a complete bowl with a wide, highly ornate reverse border, appeared to be out of her element and, we believed, ought to be somebody's mother. So now, we have created a third familial design, in addition to the "Quail Family" (page 40), with a similar design character.

RABBIT FAMILY
COMPOSITE
DESIGN

121

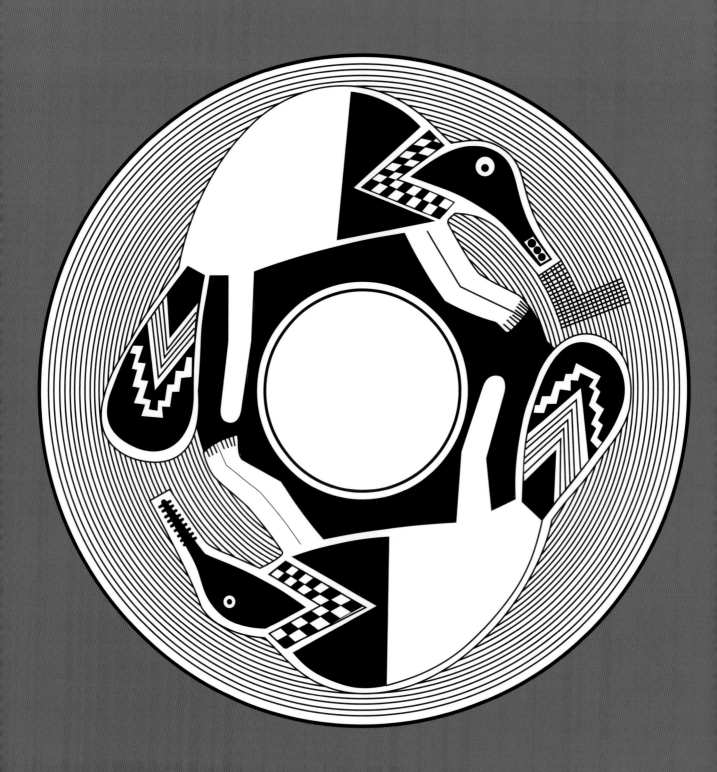

Threbig question concerning this impressively designed and delineated bowl found in the Osborn Ruin is what the attitude was of the Mimbreños toward beavers and their dam-building activities in the Mimbres River. Were the Mimbreños concerned that the beavers were destroying their carefully built irrigation systems for bringing water to their fields of corn, beans, and squash? Did they try to stop them, or did they admire their dam-building activities and try to incorporate them into their irrigation systems? Did the beavers think they were creating a lake, or is it possible that the Mimbreños thought the beavers might save the water from sinking away into the earth?

Beavers live less than twelve years in the wild. Their large incisor teeth, which continue to grow as long as they live, cause the beavers to constantly chew hard objects such as trees to keep their teeth from growing too large, preventing them from eating. Their favorite food is tree bark, mostly poplar and aspen.

This could be the only complete Mimbres bowl depicting beavers yet found. It was unearthed miles from a point on the Mimbres River where it begins to dry up and sink into the ground. Would beavers try to dam up a river where it is already terminating in the hot desert sun? From studying this bowl design, it appears that the Mimbreños had high regard for the beavers, decorating their shoulders and tails with symbols of power such as water, clouds, and checkered chevrons below their heads, possibly denoting the myriad stars in the Milky Way. The most amazing element of the design is the background of fine concentric circles that were so accurately painted by hand. They must have had a truly mysterious technique for painting them inside a bowl.

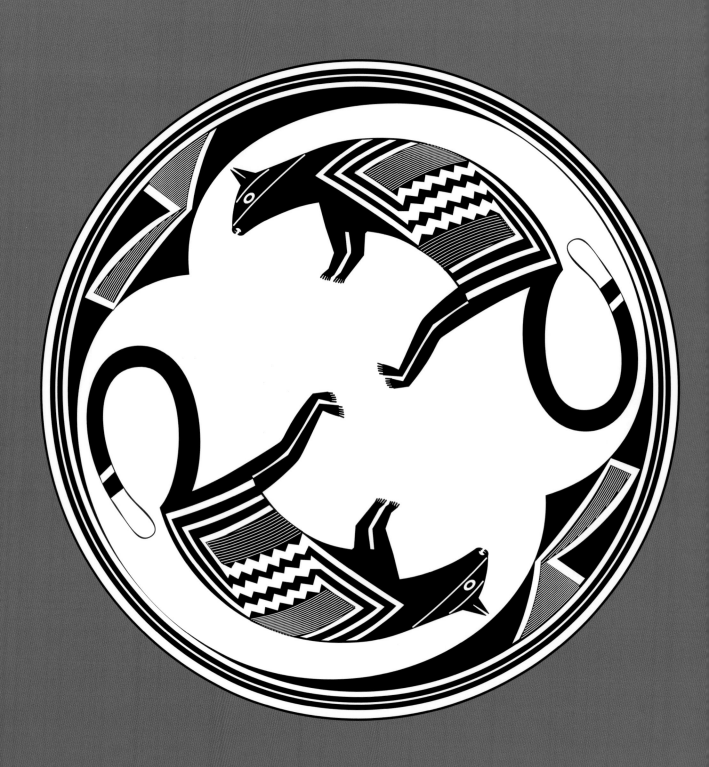

The American Procyonidae family of fur animals includes the raccoon, kinkajou, ringtail, and coati. The raccoon lives throughout the United States and Mesoamerica. The kinkajou is common from Mexico to South America, while the ringtail is found throughout the western United States and Mexico. The coati is a primarily tropical mammal now found from the border region of the U.S. and Mexico southward to Argentina.

All four animal types feed upon small mammals, plants, and fruits. The ringtail, named for the many rings, both brown and white, on its bushy tail, climbs trees like a cat, is known for its broad leaps between branches, and lives an active, nocturnal life. Contrary to the ringtail, the coati lives an active, playful life by day, sleeping at night. It is sixteen to twenty-six inches in body length and has a three-foot-long, slender, non-bushy tail that has variable numbers of rings or none and stands vertically as the coati walks. Obviously, the artist couldn't show a vertical tail within the bowl limits. Female coatis travel in bands of six to twenty, while the males travel alone except in mating season. Panthers and large owls are traditional enemies of ringtails, raccoons, and coatis. Ringtails and raccoons have been domesticated as pets, but coatis become temperamental easily and therefore do not make good pets.

This bowl design is painted with style, refinement, and accuracy in coati body and tail delineation, except that both animals have a band across the head and around the eyes that suggests the "outlaw-mask" natural to their relative, the raccoon. Possibly, it is a "warrior" symbol applied by the artist, unless the artist really intended to draw a pair of raccoons. However, these questions leave us without positive identification of the animals. The animals must have been considered to have special powers by the Mimbreños because of the large lightning symbol they applied to the bodies of both. This same lightning symbol was applied to the border of the "Pair of Scorpions" bowl (pages 98–9). It was not applied to the bodies of the scorpions themselves, because the artist apparently needed to apply concentric diamonds, which may have been clan symbols. All of which possibly indicates that both designs were created and painted by the same outstandingly talented artist.

PAIR OF COATIS

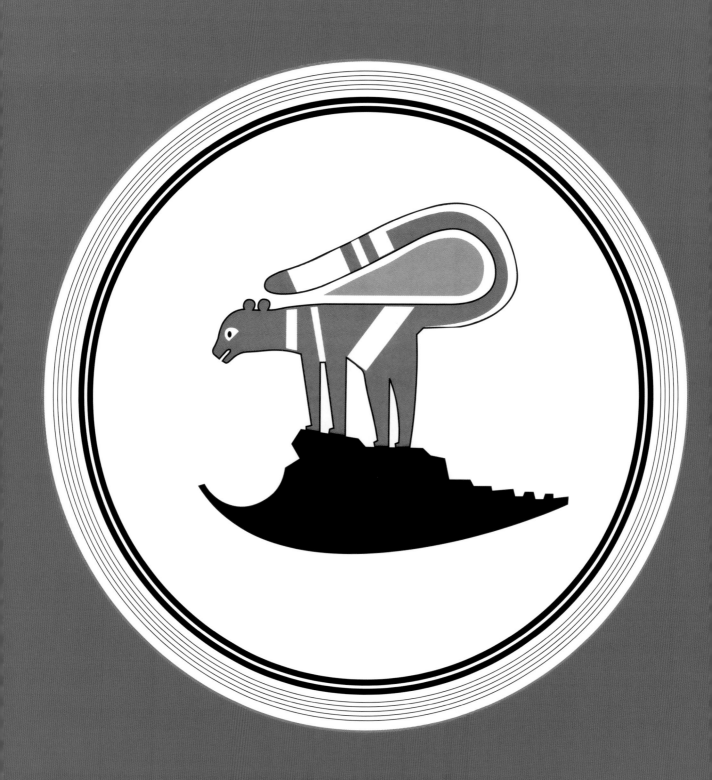

T here is no confirmation that the black jaguar known in the Valley of Mexico and Guatemala ever roamed the mountains and valleys of the Mimbres milieu in their Classic period. The tan and black spotted jaguar was still seen there as recently as 1996. However, to our knowledge, the spotted jaguar's image has never been found on Mimbres pottery. The jaguar was revered and greatly feared in Mesoamerica as the mythical, fiercely cruel god of the underworld who sacrificed both men and gods by beheading. The underworld was the place where all souls went upon their death. Maya rulers often adopted the jaguar image and name to create fear in their subjects.

In the southwestern U.S., the more common cat was and is the panther or mountain lion. Religious practice among Native Americans in the Southwest has referred only to the panther and lynx in their cults, clans, and ceremonials.

Our panther is realistic, monumental, and almost friendly. The original pot appears to have been a food bowl because of its obvious wear pattern. It is also a burial icon that has been "killed." Perhaps it was created as a food bowl for a beloved Mimbres chieftain whose personal emblem was either the black jaguar or the panther. Upon his death, the bowl with its emblematic animal was buried with his body. Certainly, this can be a considerably worthy supposition.

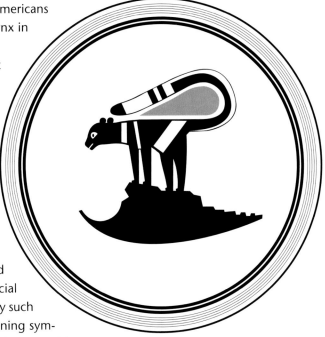

It is interesting, too, that most Mimbres illustrations of panthers are shown with white-tipped or striped long tails looping over their backs. This one has special white body stripes. Strangely, there are no species with any such white markings among today's panthers. Note the lightning symbol on the panther's rectangular body here. Were these markings applied symbols of respect for his many divine powers?

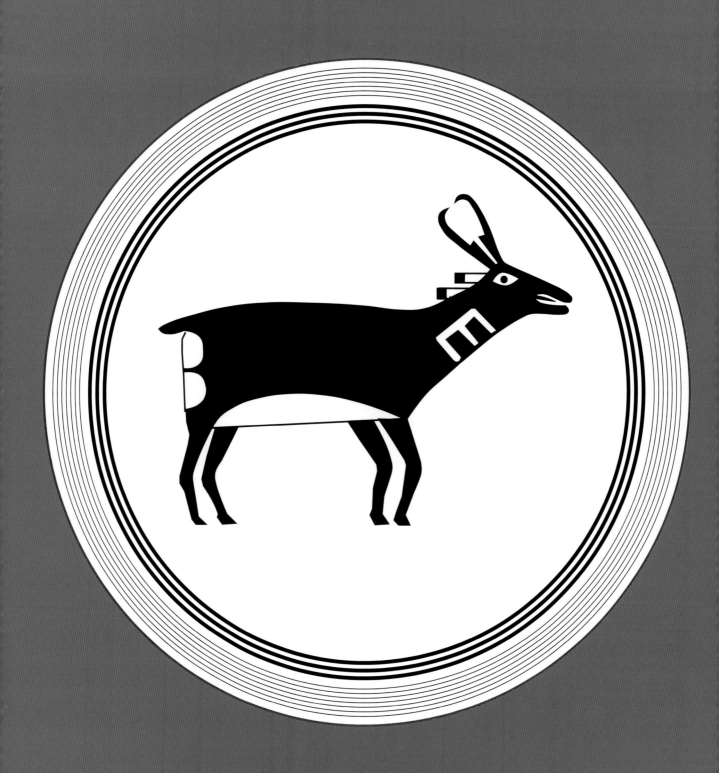

Pronghorn antelopes are believed to have been plentiful in the Mimbres valley a thousand years ago. Early Spanish settlers reported that they were still common there in the seventeenth century, but today there are very few. Antelopes were an important meat and skin source to the Mimbreños for hundreds of years. Some scholars believe that around A.D.1130, the Mimbreño population may have grown beyond the supply of wild game in the area, while their agricultural crops became inadequate as a food supply. This caused the Mimbreños to migrate, some east to the Rio Grande, some northwest to the Gila River drainage, and others south into the present-day state of Chihuahua in northern Mexico. Remains of the ceramic skills of the Mimbres artists have been excavated recently along the west side of the Rio Grande dated to the late twelfth century. It seems that in the late twelfth and thirteenth centuries many indigenous people moved to larger rivers, hoping that better crop yields could be obtained there. In this design, note that, in creating a full side view, the artist turned the pronghorns parallel to the animal's length in order to identify it as a pronghorn and mistakenly gave the antelope two left forelegs instead of a left and a right.

PRONGHORN

ANTELOPE

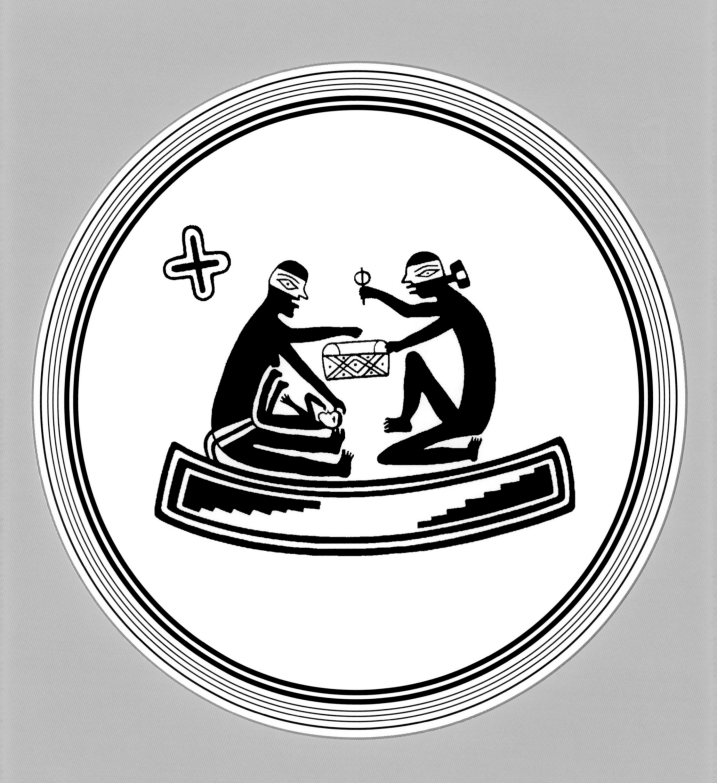

MIMBREÑOS

At long last, after seeing Mimbres ceramic artworks of geometric abstractions, birds, fishes and water life, insects, and wild animals, now you shall visit the Mimbres people themselves, as painted by their talented artisans on the inside of their food and burial bowls. Mimbres pottery paintings of the Classic period after A.D. 1000 have given us this rich visual record of their unique culture in hand-painted "snapshots" of their own daily life activities. Paintings, such as this "Child Naming Ceremony" and "Mimbreños in Ceremony" (pages 132–3), are remarkable for the skillful delineations of animated human figures in many varied activities and rituals with accuracy, sensitivity and style. On the other hand, because not all Mimbreño artists were of the same skill level, some bowl paintings, such as the "Corn Planters" (pages 134–5) and the "Deer Hunters" (pages 160–1) do not show the same level of draftsmanship of the human figure nor the same quality of painting. Still, in their own way, they have captured the spirit of the portrayed activity with surprising ability. Just try to imagine the skills required to paint these human figures in black on the inside of a twelve-inch-diameter hemispheric bowl.

We begin with the newborn Mimbreño. Many historic and contemporary Pueblo people present the newborn child to the rising sun, holding the naked child up to its rays on the morning of either the fourth or the eighth day of its life. This design surely depicts the Mimbres child naming ceremony for newborn children, as performed by a religious leader who holds a basket containing ceremonial pollen in one hand and a symbolic ritual device in the other, while the mother applies pollen to the child's forehead (opposite). Behind the mother's head is a star in the sky that may be the symbol of both the planet Venus and of Quetzalcoatl, the major god and ruler of the Toltecs, contemporaries of the Mimbreños, indicating that the day for naming was chosen by the location of Venus in the morning sky. As is traditional in many Native American tribes today, the name given first is only temporary, until later, when the child exhibits a special skill or performs a special deed that will inspire the creation and application of a permanent name.

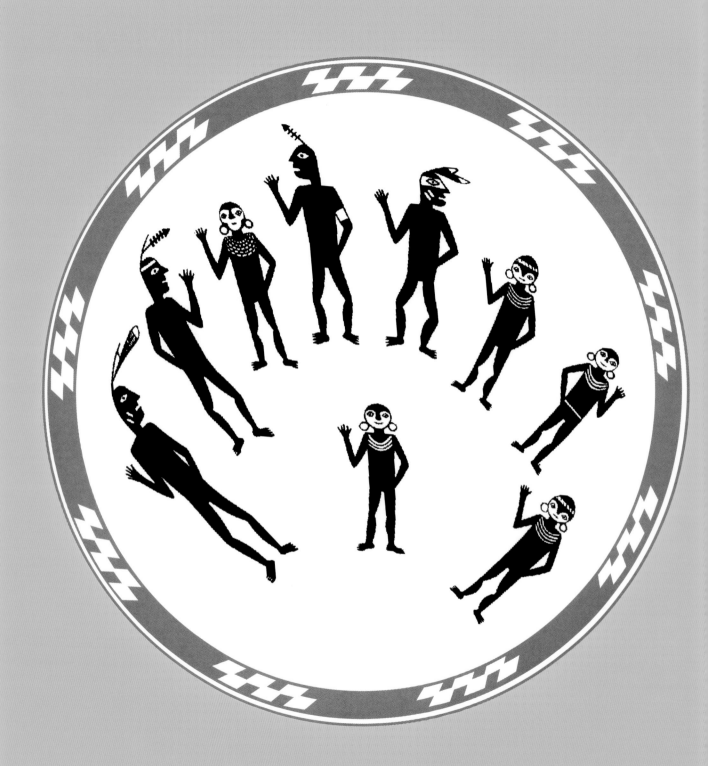

T he Mimbreños certainly must have engaged in regular and seasonal celebrations and performances thanking their gods for successful plantings, harvests, and hunts, as well as ritual petitions to their gods for rain, germination of crops, and adequate food for families.

This group of four men and five women seems to be engaging in some special kind of ceremony or ritual performance that is unknown to us. Their costumes in this presentation are nothing but neck adornments, jewelry, and face paint for the girls or young women, and headbands with a few feathers, plus face paint, for the men. One of the men wears a wide, white band of face paint around his eyes, which may be a symbol of the warrior. The two white diagonal lines on his cheeks are most probably another symbolic design. According to J. J. Brody, contemporary Pueblo people say these lines resemble those on their Hero Twins. To the Pueblos, twins represent the sons of the sun god. Twins are honored in the pantheons of many historic and contemporary Pueblo religions and in ancient Mesoamerican religions. As described in the *Popol Vuh* of the Maya, they are the sons of the corn god and engaged the cruel rulers of the underworld in competitive games before the creation of human beings. The twins defeated the underworld rulers by subterfuge and clever trickery, making life here and on earth and death in the underworld more pleasant and acceptable for everyone.

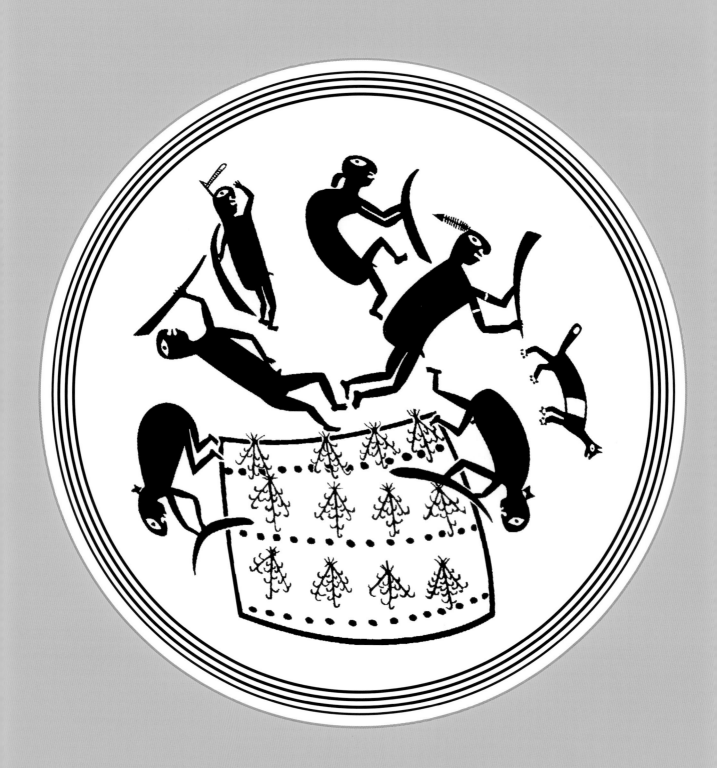

The diet of the Mimbres people may have included corn, squash, beans, amaranth, wild berries, nuts, quail, turkeys, rabbits, badgers, beavers, sheep, deer, pronghorn antelope, bears, and fish from streams. But corn always predominated in their diet, perhaps to the same extent that it has in the lives of many historic and modern Pueblo peoples who believe their mythological origin to be of corn and see themselves as "made of corn." Therefore, corn was most likely of prime importance to the Mimbres people.

The first planting of corn in spring was an important ceremony, as shown in "Corn Planters." The planting of the chieftain's fields, indicated by what may be a bobtailed lynx, emblem of his rank, involved two teams of men. One team of two men placed small corn plants in spaced holes in an outlined area, while the other team of four men laid out additional areas for planting. The Mimbres artists often rendered scenes like this from the perspective of an imaginary viewpoint above the broad field of activity. Since they painted the scene inside a hemispheric bowl, effectively employing the inside walls to create the effect of three dimensions, our drawing in two dimensions of what they did naturally distorts the effect they created. The depiction of human beings in this bowl lacks some of the refinement seen in the previous "Mimbreños in Ceremony" painting. We can imagine that, as the men planted the entire field, and after they had finished, they prayed to the corn maidens (pages 136–7) for plenty of rain, sunshine, and early germination of seeds and plants.

CORN
PLANTERS

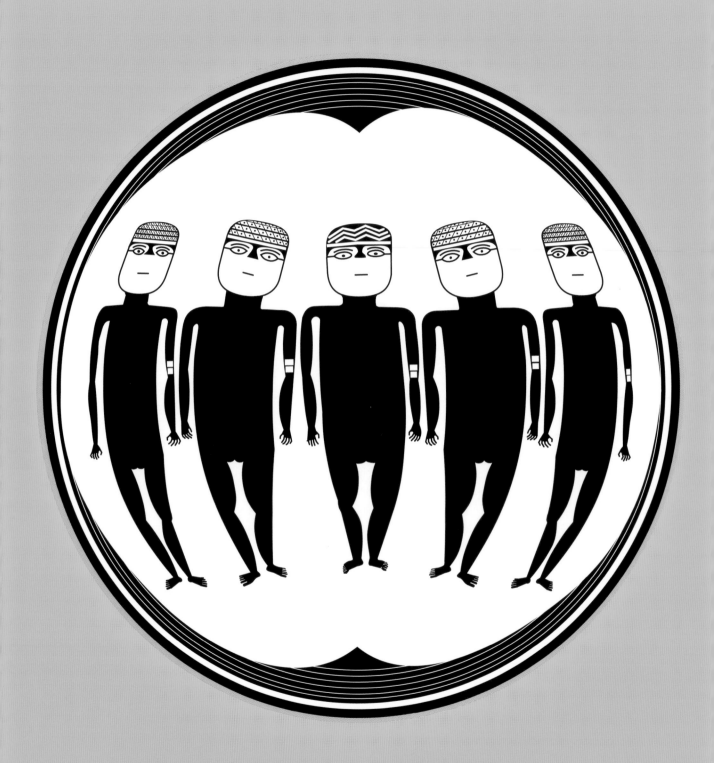

Corn, as a staple food, was so important to the Mimbreños that we believe they regularly prayed to their mythical corn maidens, sisters of the sun god. The maidens are a temperamental group, as was the weather each growing season. The Mimbres people would have been extremely careful not to offend the corn maidens and at a bountiful harvest would celebrate, offering them great honors. The five naked maidens in this design are identified by their headdresses. The center one with the wave design must be responsible for rain for the crops. The other four wear corn symbols on their headdresses representing their responsibilities for the corn's protection from the ravages of the elements, including wind, hail, drought, and insects. In historic and modern Pueblo cultures the corn maidens, as many as eight, nine, or ten of them, have continued to play a part in the agricultural spectrum. The maidens may actually be mythical sisters who represent the basic food crops and their agricultural activity throughout the seasons. At Zuni Pueblo the corn maidens are the eight sisters of the sun god, whose son, Paiyatemu, is half god and half mortal, and whose major interests are music and maidens, in particular the corn maidens. The myth is that as he pursues them and they take flight, the corn crops suffer.

CORN
MAIDENS

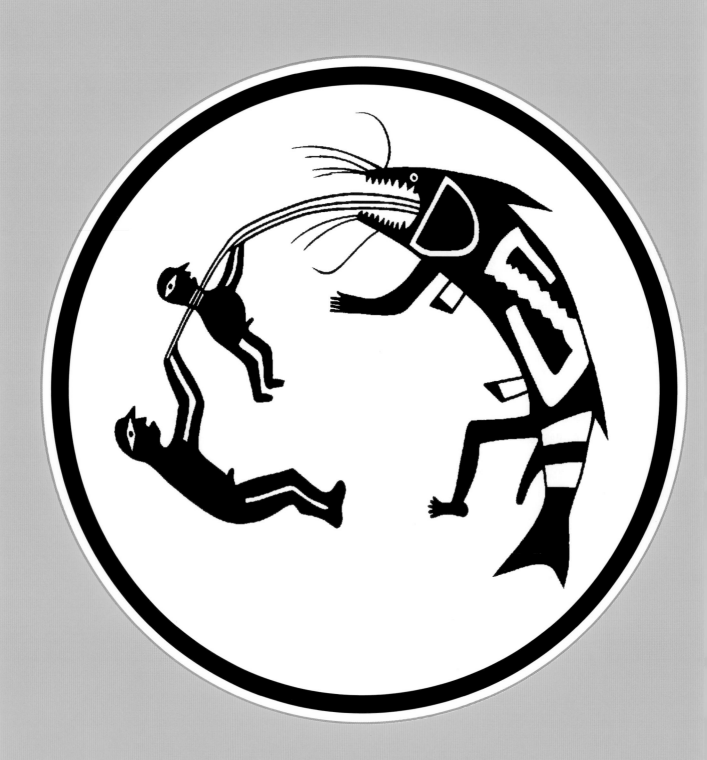

In times of drought during the growing season, the Mimbreños undoubtedly performed symbolic ritual ceremonies to produce rain. Rain must have been of utmost importance to the Mimbreños, who lived in farming communities and undoubtedly had many different ceremonies and dances to petition their gods for rain. In the "Rainmakers" painting, taken from a rare food bowl, we believe that actors depict two deities, the twin sons of the sun god, known as the "Little Hero Twins" or the "Little War Twins." Since the Mimbreños were a peaceful, farming people, their concept of war probably had more to do with hunting wild game than with making war. Actually, the twin gods are more like childish tricksters than powerful and aggressive warriors. Here they are trying to make rain by extracting it from the mouth of a giant, fierce fish figure with an S-shaped lightning symbol on its back. In this ceremonial, the twin in the background is smaller than the other one, indicating the artist's knowledge of perspective. A man inside the giant fish costume displays a human arm and legs extending below the realistic form of the giant fish. The Mimbreños developed exceptional skills in making costumes and paraphernalia for important ceremonies. Twins have been, in some way, a part of the pantheon of a great many Native American cultures. To the Maya, their mythical "Little War Twins" were important because they defeated, through clever trickery, the bloodthirsty ruling forces in the underworld before the creation of human beings by the god Quetzalcoatl.

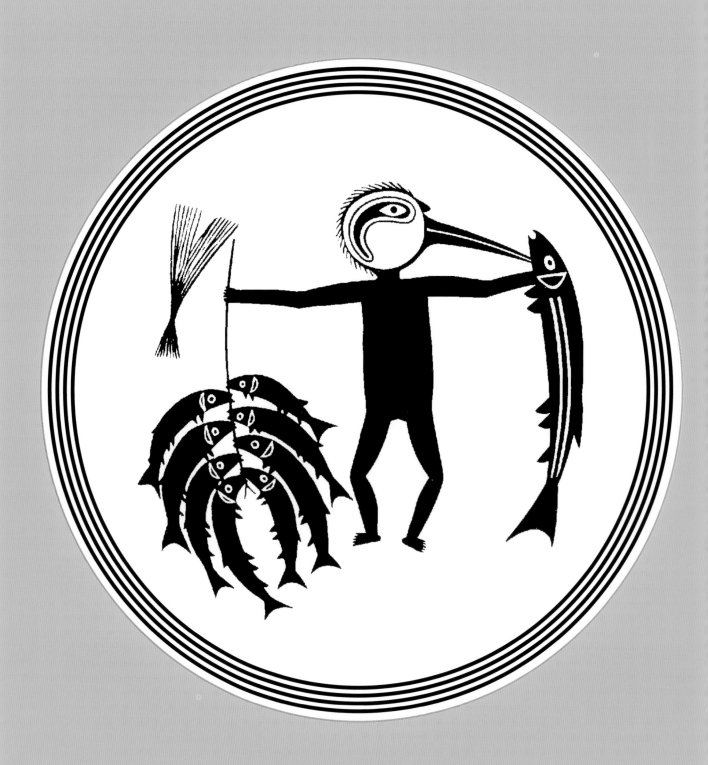

The Mimbres men developed considerable skill at catching fish. Strangely, they often appear to have worn masks or headdresses to disguise themselves as the creature they were hunting or fishing, as shown here and in the "Turkey Hunters" (pages 148–9). Deer hunters often wore antlers on their heads, perhaps obtained from a previous hunt, and the parrot trainer wore a mask simulating the parrot's head and beak (pages 148–9). Surprisingly, the headdress worn by this obviously successful fisherman has the markings of a bird known today as Wilson's phalarope, a bird slightly larger than a sandpiper that swims on shallow waters and spins in the water to churn up food from the bottom. The bird neither catches nor eats fish because its bill is too narrow to swallow them. Instead, it ingests algae and other tiny forms of life. The markings on the fisherman's strange bird headdress are found only on the phalarope in the spring and summer. In the winter, the phalarope migrates through Mexico. On the upper left of this painting is shown a snare made of reeds used by the fisherman to catch his fish. How can these strange phenomena be explained? It has been proposed that this challenging bowl design might illustrate some mysterious Mimbres myth, or that these masks and headdresses may represent supernatural beings. Again, there are many questions and few answers.

PROUD
FISHERMAN

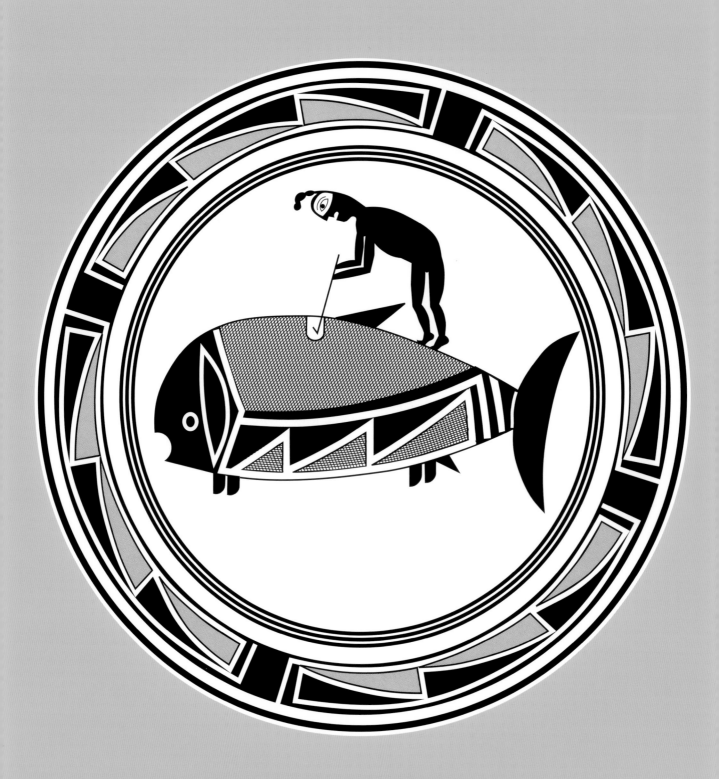

This design depicts what appears to be a beached whale, associating it with the "Dancing Dolphins" seen on the bowl on page 74. Both of these bowls seem to have a different design character from those of the Mimbreños, suggesting a question of their origins.

MAN INSPECTING

A BEACHED

WHALE

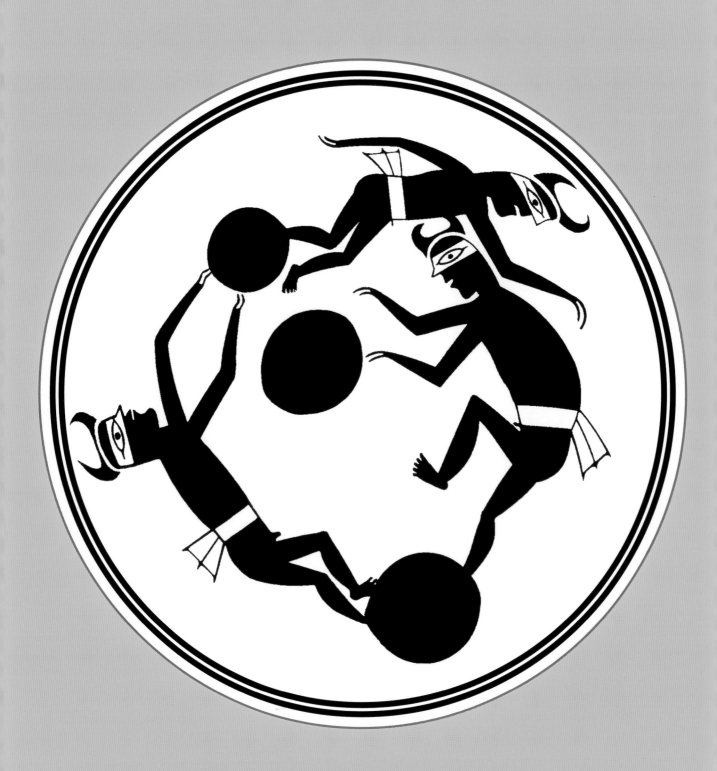

T he game depicted here by the Mimbreños appears to be based on characteristics of beetles. Evidently, the Mimbreños were very skilled at making masks, headdresses, and costumes. Note the pincers-like headdress and wings on the players backs. No one has yet deciphered the rules or methods of playing these various games but it might have been related to the dung beetle's habit of making a hole in the ground and depositing its eggs in a ball of dung, then rolling the ball into the hole for incubation. The three round, black forms shown might represent a ball or balls, and a hole or holes in the ground, the object being to get the ball into the hole by throwing or kicking it, as in today's basketball or soccer. Pre-Columbian architecture and artifacts show examples of ball games played in Mesoamerica to the American Southwest. It has been speculated that the game might have related to the Toltec beetle god known as Pinahuiztli (pages 96–7), whose idealized image represented the Toltec astronomical system. Maya ball courts were used by the elite rulers to determine who would be the next human sacrifice to their bloodthirsty gods. The Maya created the ball from a hollow gourd or human skull encased in rubber. In the final analysis, this Mimbreño artist was outstandingly gifted with special skills in illustrating the violent action animation of the three muscular athletes who may or may not have been playing for their very lives.

BEETLE
BALL GAME

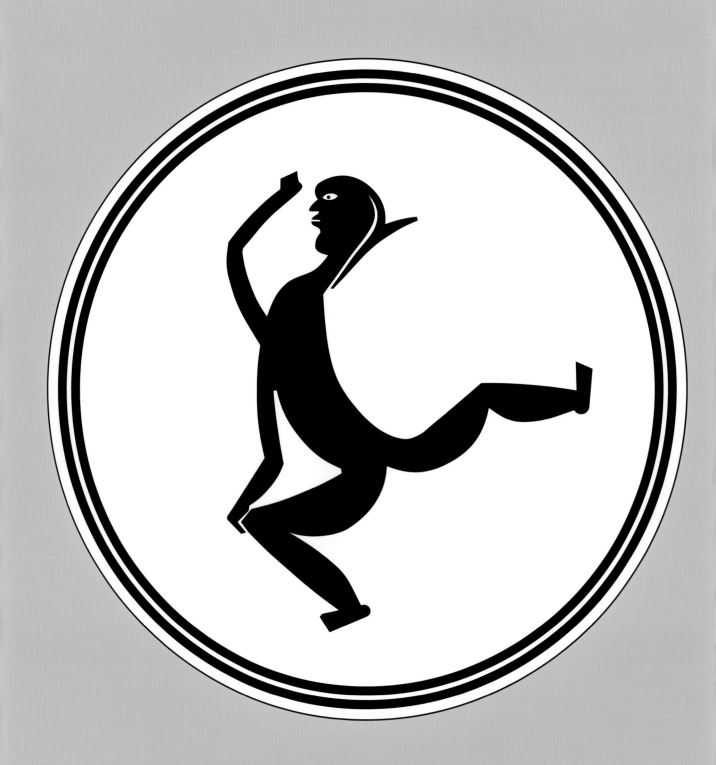

W hy did the Mimbreños and their descendants dance? Probably for rain! Other cultures in Mesoamerica and the Southwest also invoked rain gods, for example, the Toltecs, Mogollon, Hohokam, and Anasazi. Contemporary Pueblo cultures honor and invoke the horned water serpent. The horned water serpent presides over all the waters of the earth and is associated with lightning because of his zigzag course and his striking power. Lightning most often accompanies rain. Because the serpent lives in a hole in the earth, he is thought to have contact with the underground waters, the spirits of deceased ancestors, and the many deities of the underworld.

In periods of drought, the dancing never ends. Rain dances may have been performed in the shrine of the horned water serpent. This young dancer wears only the headdress of the horned water serpent, known in the pantheon of the modern Hopi as "Palulukon" and to the Zunis as "Kolowisi," guardian of all springs, streams, and lakes. (See "Horned Water Serpent," pages 80–1; and "Shrine of the Crane Spirit," pages 60–1.)

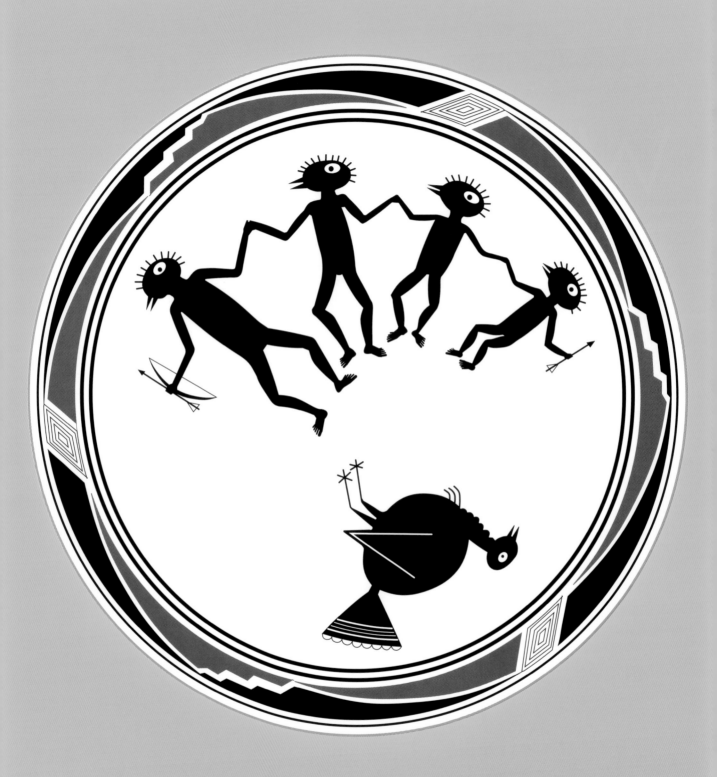

Here you see a picture of Mimbres men wearing disguises when hunting. This time it is a turkey they are after, and they are wearing turkey headdresses to confuse it and capture it alive (see "Proud Fisherman," pages 140–1, and "Deer Hunters," pages 160–1). Turkeys, being a little slow to frighten and fly away, sometimes could be caught by a group like this by offering cornmeal without shooting arrows. These hunters are seeking to capture the turkey and possibly to add to the number of birds they are raising for food and feathers. Their colorful feathers could be used for body adornment and for prayer feathers that they placed in shrines as offerings and appeals to their gods. This is either a family group made up of a father and three sons of different ages or we are viewing another use of size reduction as an expression of perspective to suggest that each of the three men is a little farther behind the dominant figure. Since they are not ready to shoot with bow and arrow at this close range and their hands are joined to surround the turkey, it is obvious that they are trying to capture the bird directly. This original bowl was painted in a conventional black-on-white glaze.

TURKEY
HUNTERS

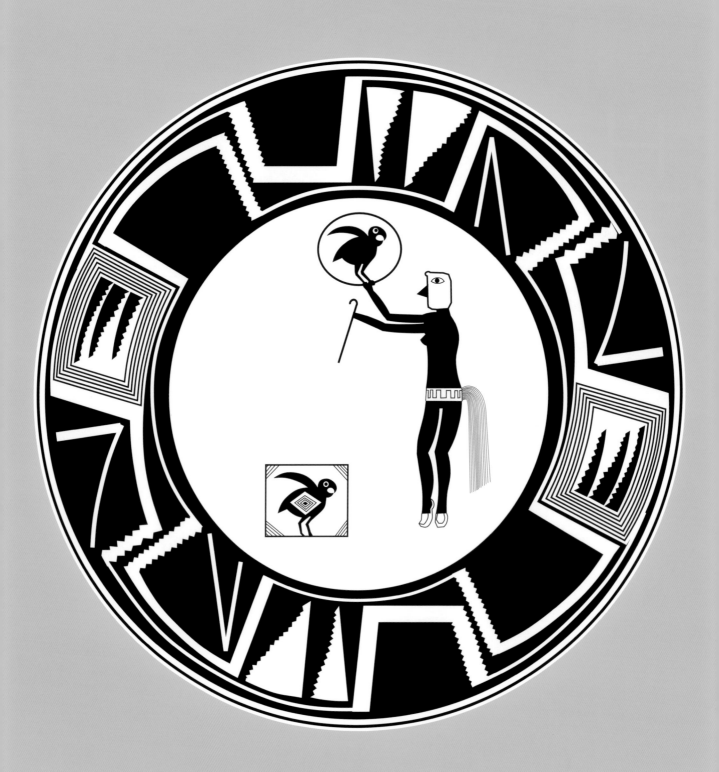

The presence of colorful macaws native to the tropical lowlands of Mexico at Classic Mimbres archaeological sites suggests trade relationships with cultures to the south. Scarlet macaws and macaw feathers have also been found to the north at Anasazi sites in Chaco Canyon and to the south at Casas Grandes in Chihuahua, Mexico. Other trade goods found in Mimbres burials include copper bells, shell ornaments, and turquoise.

In the center of this bowl the woman trainer wears a handmade mask or disguise, seemingly for the same purpose as deer hunters wore antlers and the "Turkey Hunters" (pages 148–9) and "Proud Fisherman" (pages 140–1) wore masks. It is a question why the parrot in the lower cage is marked with concentric diamonds, while the one in the hoop is not. The wide black border includes two large shrine symbols indicating the special purpose of this very ornate Mimbres bowl.

WOMAN
PARROT TRAINER

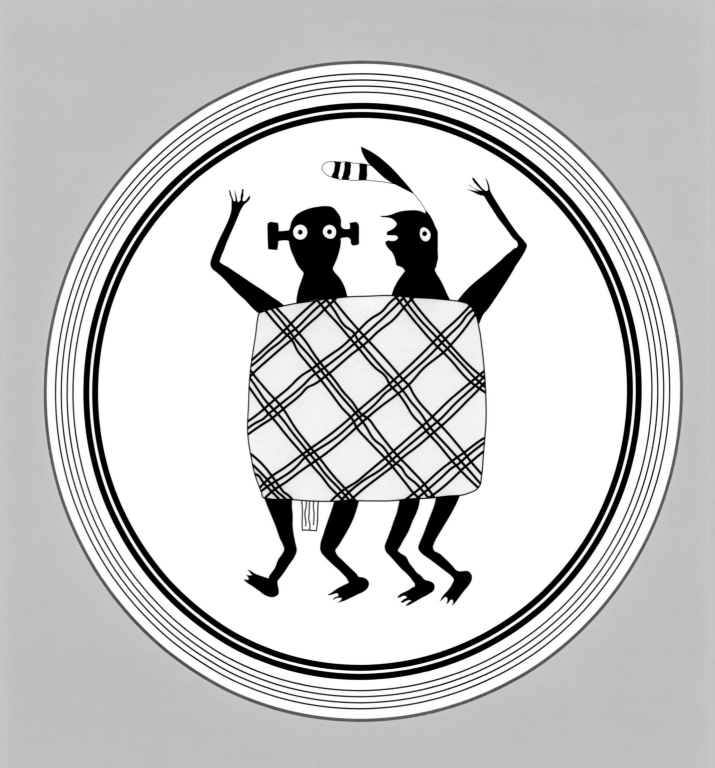

Almost nothing is known today about the courting and wedding rituals of the Mimbreños, except by analogy with the rituals of contemporary Pueblo peoples. Nevertheless, this Mimbres bowl painting may describe a Mimbres "wedding." It appears that the ritual might have been as simple as that of the young man, identified by the feathers in his hair, taking the young maiden under his blanket. This painting, typically viewed from above as the Mimbreño artists viewed so many of their scenes, shows the young couple lying together under the wedding blanket. If the Mimbres culture were matriarchal, as occurs among some historic and modern Pueblos, the young couple might live with the bride's family. If the culture were patriarchal, they could live with the groom's family under the authority and tutelage of family leaders, until their first child was born.

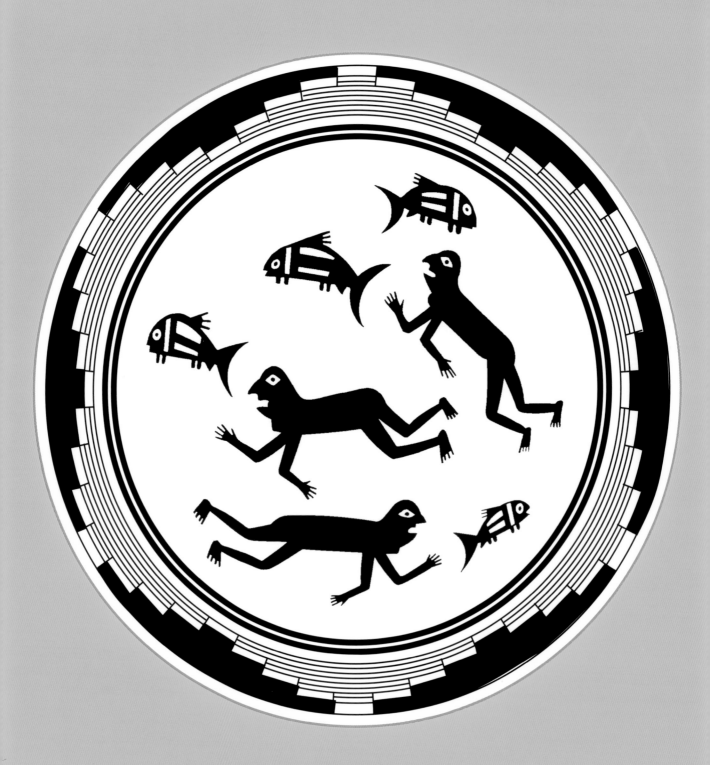

ontemporary Pueblo people divide the world into seven parts: the four directions, plus the zenith, the underworld, and the middle place, their home. The Mimbreños may share this cosmology with today's Pueblos. This attractive Mimbres bowl design is very evocative of a Maya myth. The Maya were very frightened of death. Their ruthless, bloodthirsty jaguar god sacrificed gods and men by decapitation. The Maya believed in an underworld where all people's spirits spent their afterlives. This bowl design speaks graphically of a group of travelers who had lost their way and came to a bridge over a stream where they were met by an evil, underworld wizard who destroyed them by casting them into the stream, and changing them into fish. This memorable bowl design may illustrate the myth and the travelers' tragic transformation into fish. The Mimbreños seem to have had peaceful lives in their village settlements, unlike their neighbors to the south in Central Mexico.

UNDERWORLD

MYTH

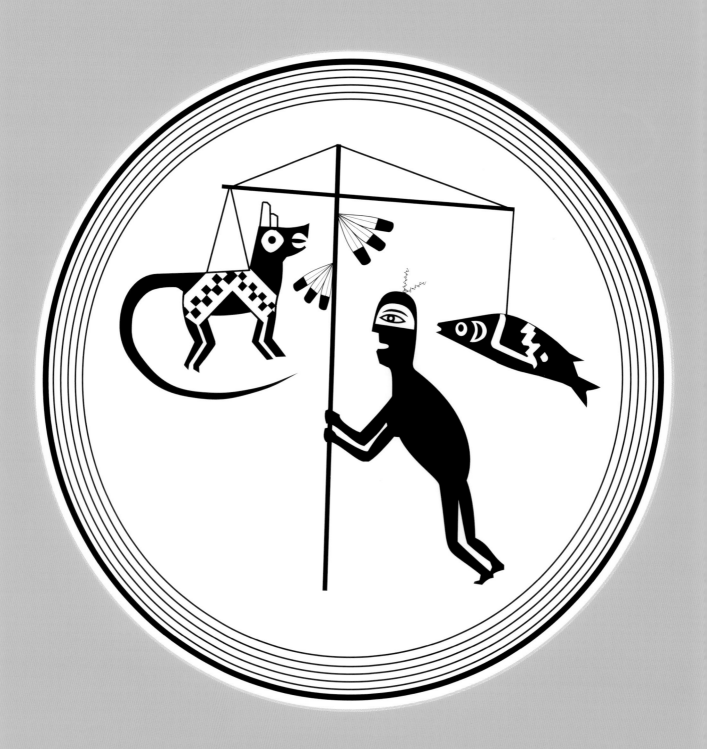

The balance staff held by a human figure in this bowl design probably had multiple uses in Mimbres culture. Most likely it was used effectively by traders to evaluate comparative weights and values for simple trading. It may also have been used by a shaman or tribal chieftain to settle differences between clans or individuals. The dog and fish shown may have been symbols of clans who were in disagreement within the tribe. Note the three prayer feathers attached to each side of the staff, which may represent the prayers or pleas of each clan. The human figure may represent a shaman who has now heard each clan's plea and is using the balance staff to illustrate his important decision to settle their disagreement. It appears that the Mimbres people had a peaceful culture and good relations both within the tribes and with their neighbors. Mimbres painted pottery leads us to believe that they were primarily interested in their natural environment rather than in making war. Evidence is lacking that the Mimbres engaged in war with their neighbors. The problem of the destruction of Mimbres archaeological sites by looters makes further scientific investigation of the topic of warfare extremely difficult.

SHAMAN'S
BALANCE STAFF

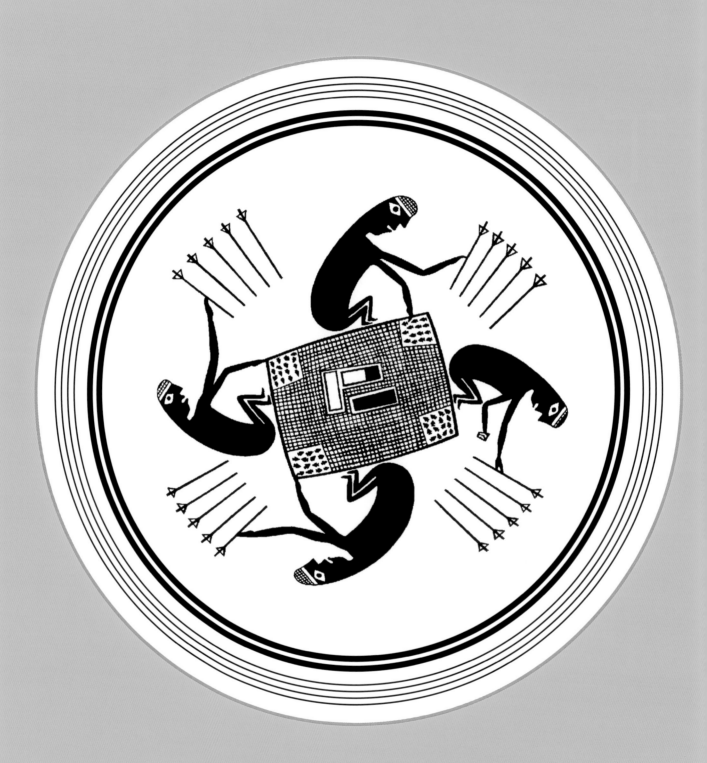

M imbres pottery paintings of the Classic period between A.D.1000 and A.D.1150 have given us the rich visual record of their culture that we have today. Illustrations of the people in group activities, such as this "Arrow Makers" design, were often depicted from above, in plan view. In this painting four men are seated around a mat. On the four corners of the mat are quantities of arrowheads for mounting on the arrows laid out in groups of five at the fingertips of the human figures. This remarkable design could be the first-recovered example of a production assembly line in the Western Hemisphere! Archaeologists tell us that the Mimbreños used the bow and arrow for hunting game as early as A.D.500. Mesoamericans such as the Toltecs were still using atlatls, wooden shafts used to project spears and darts, as late as the Mimbres Classic period.

The Mimbreños did not leave substantial evidence of being warlike but they needed to hunt game with which to feed their growing population. This effort required intense cooperative labor. The headdresses of the four men may be war symbols, but in this situation the war was probably not against their neighbors but against wild animals for food to feed their families. Soon after A.D.1100, it became apparent that their community's numbers had grown and the wild game in the mountains and valleys was becoming insufficient. It is believed that early in the twelfth century, broad-ranging droughts occurred, reducing the yields of their crops of corn, beans, and squash. So, between A.D.1130 and A.D.1150, many Mimbreños migrated elsewhere in the region in search of more fertile, less crowded lands.

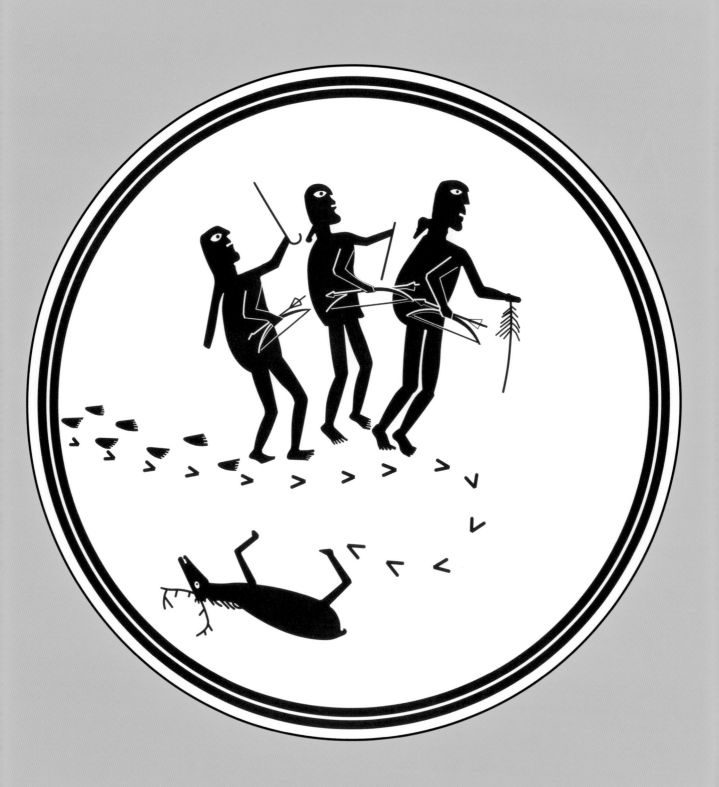

Mimbres hunters surely hiked regularly into the mountains, hunting and tracking animals such as deer, antelope, sheep, and bear for food and skins for winter clothing. The white background suggests that they are barefoot while tracking a deer in the mountain snow. They may even be wearing deerskin jackets. Though other designs show deer hunters wearing antlers on their heads, these hunters do not wear disguises. Perhaps that's why the deer has doubled back to escape while they look the other way, losing his tracks. Painted on the inside wall of the hemispheric bowl, the deer appears to be lying down in the snow but is actually walking upright on only two legs. On the opposite wall of the bowl, the hunters walk upright. Each one of the hunters carries a bow and one arrow in his right hand and a prayer stick in his left hand. Some Mimbres artists declined to draw hands, and sometimes they drew both arms attached to the same shoulder, as seen here.

Prayer sticks and prayer feathers were made and carried by historic Pueblo peoples to express hunters' petitions to the gods for help on the hunt. The drawing from the 1914 book by J. Walter Fewkes on Mimbres pottery shows a prayer stick that is eight inches long. It is possibly made of willow, which flourishes all along the waters of the Mimbres (which means "willow" in Spanish) River. Willow bends flexibly without breaking. Each hunter's prayer stick is unique. The leader has one with multiple feathers attached, which he seems to be holding forward and low, as one would hold a divining rod, possibly for guidance by the gods in tracking the deer. The second hunter has a straight prayer stick, which he holds forward at shoulder level, while the third hunter holds a curved prayer stick similar to our illustration, forward and up high. These prayer sticks are Mimbres mysteries. The design is rust red-on-white, caused by too much oxygen during firing.

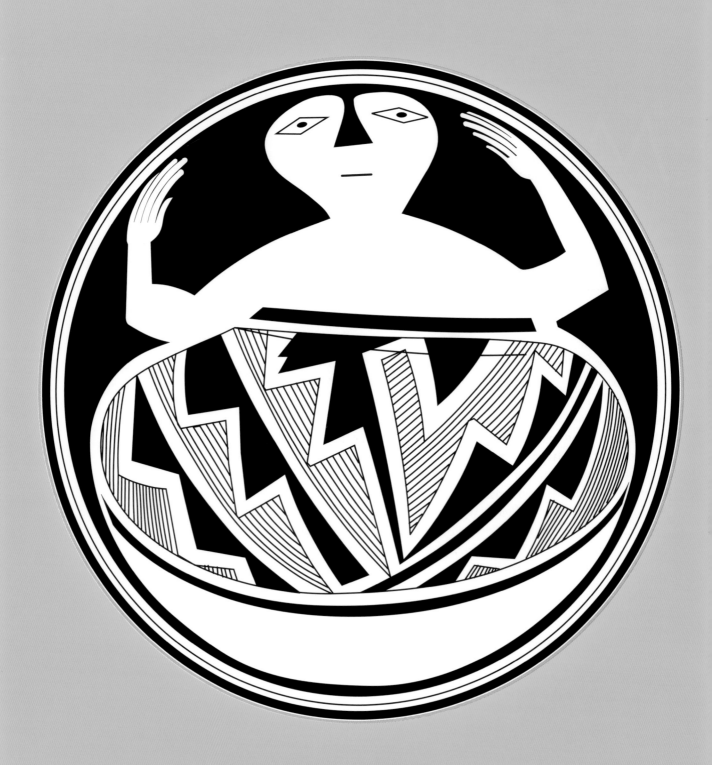

T his Mimbres pottery design is unique for many reasons, not the least of which is that it depicts a painted bowl inside of a painted bowl. In addition, it was obviously created as a celebration of the life of a highly respected Mimbres pottery artist upon the death and for the burial of that artist. The Mimbres traditional ritual was to bury a deceased person and place a ceramic bowl that was "killed" over his or her head. There has been a question among anthropologists and art historians as to whether such bowls were specially painted for a person's burial to honor that person or whether the person's personal food bowl was used. It appears that this bowl design was painted for the burial ceremony. However, many other burial bowls showed evidence of wear from use as a food bowl.

The longer this bowl design is studied, the more questions arise about it. You may have observed that the human figure is actually united with the internal bowl—they are one. Also, it is impossible to determine the gender of the human figure. Shall we assume that the human figure was the artist who had just died or is it the spiritual image of the artist, who was totally dedicated to the potter's art and that is why the image and the bowl are unified? Was this bowl design conceived by another admiring or loving artist or by a family member? Can it be that the deceased artist conceived and painted this bowl for burial, knowing that he or she was dying? What is the significance of the raised hands of the human figure? Our knowledge of other cultures both before and after the Mimbres Classic period tells us that the figure's hands are raised in prayer to the appropriate god or gods, an expression of the natural human desire to be transported from the underworld to the zenith.

Finally, is the design in the bowl-within-a-bowl that of lightning or corn leaves? Something in the design doesn't seem to belong, a line drawn from the upper left corner of the internal bowl that declines slightly across the bowl and terminates in space. Might this unfinished or misplaced line symbolize an early death, an unfinished lifeline? Also, what is the function of the black bar drawn between the internal bowl and the human figure? After considering all of these unanswered questions, we must realize that we will never have all the answers. These mysteries only add to, rather than detract from, our appreciation of the remarkable creativity and spirit of the greatly talented Mimbres Classic potters.

SPIRIT OF A
MIMBRES
POTTER

BIBLIOGRAPHY

Andrews, Ted
 1997 *Animal-Speak: The Spiritual and Magical Powers of Creatures Great and Small.* Lewellyn Publications, St. Paul, MN.

Anyon, Roger, Patricia A. Gilman, and Steven A. LeBlanc
 1981 A Reevaluation of the Mogollon-Mimbres Archaeological Sequence. *The Kiva* 46(4):209-55.

Anyon, Roger and Steven A. LeBlanc
 1984 *The Galaz Ruin: A Prehistoric Mimbres Village in Southwestern New Mexico.* Maxwell Museum of Anthropology Series and University of New Mexico Press, Albuquerque.

Bradfield, Wesley
 1931 Cameron Creek Village: A Site in the Mimbres Area in Grant County, New Mexico. *School of American Research Monograph* 1, Santa Fe.

Bradfield, Wesley and L. B. Bloom
 1928 A Preliminary Survey of the Archaeology of Southwestern New Mexico. *El Palacio* 24(6): 98–112.

Brody, J. J.
 1977 *Mimbres Painted Pottery.* School of American Research, Santa Fe and University of New Mexico Press, Albuquerque.
 1991 *Anasazi and Pueblo Painting*, School of American Research, Santa Fe, and University of New Mexico Press, Albuquerque.

Brody, J. J., Catherine J. Scott, and Steven A. LeBlanc
 1983 *Mimbres Pottery: Ancient Art of the American Southwest.* Hudson Hills Press, New York.

Brody, J. J. and Rina Swentzell

1996 *To Touch the Past: The Painted Pottery of the Mimbres People.*
 Hudson Hills Press, New York, in association with Frederick R.
 Weisman Art Museum at the University of Minnesota,
 Minneapolis.

Bruggmann, Maximilien, and Sylvio Acatos

1990 *Pueblos: Prehistoric Indian Cultures of the Southwest.*
 Facts on File, Inc., New York.

Carr, Patricia

1979 Mimbres Mythology. *Southwestern Studies, Monograph No. 56,*
 Texas Western Press, University of Texas, El Paso.

Clemons, Russell E., Paige W. Christiansen, and H. L. James

1960 *Southwest New Mexico: Scenic Trips to the Geologic Past,*
 No. 10. New Mexico Bureau of Mines and Minerals, Socorro.

Coe, Michael D.

1973 *The Maya Scribe and His World.* The Grolier Club, New York.

1999 *The Maya,* 6th ed., Thames and Hudson, New York.

Cordell, Linda S.

1984 *Prehistory of the Southwest: A Volume in the New World*
 Archaeological Record Series. School of American Research,
 Santa Fe, and Academic Press, Inc., San Diego.

Cosgrove, Harriet S. and Cornelius B.

1932 The Swarts Ruin: A Typical Mimbres Site in Southwest New
 Mexico. *Papers of the Peabody Museum of Archaeology and*
 Ethnology 15(1). Harvard University, Cambridge.

Davies, Nigel

1977 *The Toltecs, Until the Fall of Tula.* University of Oklahoma Press,
 Norman.

1979 *The Toltec Heritage, From the Fall of Tula to the Rise of*
 Tenochtitlan. University of Oklahoma Press, Norman.

1982 *The Ancient Kingdoms of Mexico.* Allen Lane, Penguin Books,
 London.

Diehl, Richard A.
1983 *Tula: The Toltec Capitol of Ancient Mexico*. Thames & Hudson, London.

Di Peso, Charles C., John B. Rinaldo, and Gloria J. Fenner
1974 Casas Grandes: A Fallen Trading Center of the Gran Chichimeca. Vols.1–3, *Amerind Foundation Publication* 9. Dragoon AZ and Northland Press, Flagstaff.

Evans, Roy H., R. Evelyn Ross, and Lyle Ross
1984 *Mimbres Indian Treasure in the Land of Baca: Excavating an Ancient Pueblo Ruin*. The Lowell Press, Kansas City.

Ferdon, Edwin N., Jr.
1955 A Trial Survey of Mexican-Southwestern Architectural Parallels. *School of American Research Monograph* 21, Santa Fe.

Ferguson, William M. and John Q. Royce
1985 *Maya Ruins in Central America in Color: Tikal, Copan and Quirigua*. University of New Mexico Press, Albuquerque.

Fewkes, Jesse Walter
1914 Archaeology of the Lower Mimbres Valley, New Mexico. *Smithsonian Miscellaneous Collections* 63(10), Washington, D.C.
1916 Animal Figures in Prehistoric Pottery from the Mimbres Valley, New Mexico. *American Anthropologist* 18(4), (1916): 535–45.
1919 Designs on Prehistoric Hopi Pottery. *Bureau of American Ethnology, 33rd Annual Report for the Years 1911–1912*: 207–84. Smithsonian Institution, Washington, D.C.
1923 Designs on Prehistoric Pottery from the Mimbres Valley, New Mexico. *Smithsonian Miscellaneous Collections* 74(6), Washington, D.C.
1924 Additional Designs on Prehistoric Mimbres Pottery. *Smithsonian Miscellaneous Collections* 76(8), Washington, D.C.
1973 *Prehistoric Hopi Pottery Designs*. Dover Publications, Mineola, N.Y.
1987 *The Mimbres: Art and Archaeology*. Avanyu Publishing, Inc., Albuquerque.

Frazier, Kendrick
 1997 *People of Chaco: A Canyon and Its Culture.* W. W. Norton & Co.,
 New York.

Gabriel, Kathryn
 1991 *Roads to the Center Place: A Cultural Atlas of Chaco Canyon and
 the Anasazi.* Johnson Publishing Company, Boulder, CO.

Gallenkamp, Charles
 1986 *Maya: The Riddle and Rediscovery of a Lost Civilization.*
 3rd rev. ed. Viking/Penguin, Inc., New York.

Hancock, Graham
 1995 *Fingerprints of the Gods: Evidence of Earth's Lost Civilization.*
 Crown Publishers, New York.

Hancock, Graham and Santha Faiia
 1998 *Heaven's Mirror: Quest for the Lost Civilization.* Three Rivers Press
 and Random House, New York.

Haury, E. W.
 1936a The Mogollon Culture of Southwestern New Mexico.
 Medallion Papers 20, Gila Pueblo, Globe, AZ.
 1936b Some Southwestern Pottery Types, Series IV. *Medallion Papers* 19,
 Gila Pueblo, Globe, AZ.

Harris, Joseph A.
 1999 Tantalizing Turquoise. *Smithsonian Magazine*, August 30 (5):
 70–80.

Kabotie, Fred
 1949 *Designs from the Ancient Mimbreños with a Hopi Interpretation.*
 Graborn Press, San Francisco.

LeBlanc, Steven A.
 1982 Temporal Change in Mogollon Ceramics. In *Southwestern
 Ceramics: A Comparative Review*, edited by A. H. Schroeder,
 pages 107–21. *Arizona Archaeologist* 15, Arizona Archaeological
 Society, Phoenix, AZ.

1983 *The Mimbres People: Ancient Pueblo Painters of the American Southwest*. Thames and Hudson, New York.

1986 Development of Archaeological Thought on the Mimbres Mogollon. In Emil Haury *Prehistory of the American Southwest*, edited by J. J. Reid and D. E. Doyel, pages 297–304, University of Arizona Press, Tucson.

1999 *Prehistoric Warfare in the American Southwest*. University of Utah Press, Salt Lake City.

Lekson, Stephen H.

1992 An Archaeological Overview of Southwestern New Mexico (Final Draft). Prepared for the New Mexico Historic Preservation Division. Human Systems Research, Inc., Las Cruces, N.M.

1999 *The Chaco Meridian: Centers of Political Power in the Ancient Southwest*. Altamira Press, Walnut Creek, CA.

Lister, Robert H. and Florence G.

1980 *Chaco Canyon: Archaeology and Archaeologists*. University of New Mexico Press, Albuquerque.

Mitchell, Robert T. and Herbert S Zim.

1977 *Butterflies and Moths: A Guide to the More Common American Species*. Golden Press, New York.

Moore, Sabra

1997 *Petroglyphs: Ancient Language/Sacred Art*. Clear Light Publishers, Santa Fe.

Moulard, Barbara L.

1984 *Within the Underworld Sky: Mimbres Ceramic Art in Context*. Twelvetrees Press, Pasadena, CA.

Nelson, Margaret C.

1998 *Mimbres During the Twelfth Century: Abandonment, Continuity, and Reorganization*. University of Arizona Press, Tucson.

Nesbitt, Paul H.

1931 The Ancient Mimbreños, Based on Investigations at the Mattocks Ruin, Mimbres Valley, New Mexico. *Logan Museum Bulletin* 4, Beloit College, Beloit, WI.

Ortiz, Alfonso
 1969 *The Tewa World: Space, Time, Being, and Becoming in A Pueblo Society.* The University of Chicago Press, Chicago, IL.

Patterson, Alex
 1992 *A Field Guide to Rock Art Symbols of the Greater Southwest.* Johnson Books, Boulder, CO.
 1993 *Hopi Pottery Symbols, Based on Work by Alexander M. Stephen: ottery of Tusayan.* Johnson Books, Boulder, CO.

Robbins, Chandler S.; Bertel Bruun, and Herbert S Zim.
 1966 *Birds of North America: A Guide to Field Identification.* Golden Press, New York.

Sabloff, Jeremy A.
 1996 *The Cities of Ancient Mexico, Restructuring a Lost World.* Thames & Hudson, Inc., New York.

Shafer, H. J.
 1991 Archaeology at the NAN Ruin: 1986 Interim Report. *The Artifact* 29(2):1–42.

Snodgrass, O. T.
 1974 *Realistic Art and Times of the Mimbres Indians.* Privately printed, El Paso, TX.

Stephen, Alexander M.
 1969 *Hopi Journal.* AMS Press, New York. Reprinted from 1936 edition, Columbia University Press, NY.

Tedlock, Dennis
 1997 *Popol Vuh: The Mayan Book of the Dawn of Life.* Simon & Schuster, N.Y.

Thompson, J. Eric
 1954 *The Rise and Fall of Maya Civilization.* University of Oklahoma Press, Norman.
 1970 *Maya History and Religion.* University of Oklahoma Press, Norman.

Thompson, Marc

 1994 The Evolution and Dissemination of Mimbres Iconography.
 In *Kachinas in the Pueblo World*, edited by Polly Schaafsma, pages
 93–105. University of New Mexico Press, Albuquerque.

Tomkins, Peter

 1987 *Mysteries of the Mexican Pyramid.* Harper & Row Publishers.

Tyler, Hamilton A.

 1963 *Pueblo Gods and Myths.* Civilization of the American Indian Series
 71, University of Oklahoma Press, Norman..

Woosley, Anne I. and John C. Ravesloot

 1993 Culture and Contact: Charles Di Peso's Gran Chichimeca. *Amerind*
 Foundation New World Studies, Series 2. Amerind Foundation,
 Dragoon, and University of New Mexico Press, Albuquerque.